# How to Draw
# MANGA
## IN SIMPLE STEPS

*Yishan Li*

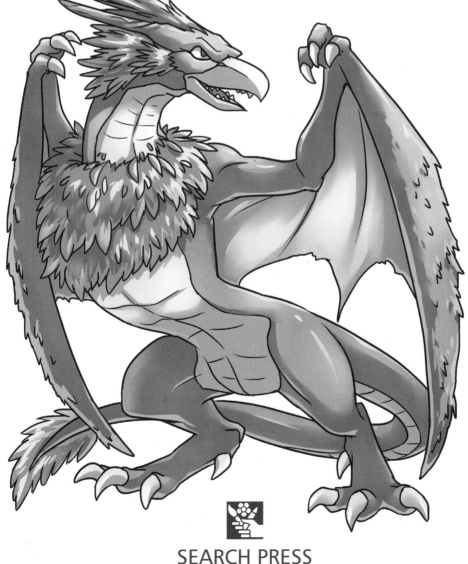

SEARCH PRESS

# CONTENTS

## Introduction

## Manga Animals

## Manga Chibis

## Manga Myths & Legends

# INTRODUCTION

Professional comic artist, Yishan Li, is an expert in drawing manga. This step-by-step collection of a selecton of her illustrations provides you with a diverse and exciting range of fun and fictitious characters to draw.

Manga originated in Japan and has since grown to have an impressive and worldwide following. With this book, you can learn the basics of manga drawing, using Yishan's illustrations as an inspiration and starting point to help you draw in the unique manga style.

The method of manga illustration is simple: basic geometric shapes like circles, ovals, squares, rectangles and lines evolve, stage by stage, into the finished forms. In order to make the sequences easier to follow, different coloured lines are used for each of the stages. The colours act as a guide, with new shapes built on to old ones, and distinguishing features added as the images develop. The penultimate stages show a black-and-white, finished drawing of the figure, and the final stage is a full colour image of the finished piece.

When you are following the steps, use an HB, B or 2B pencil. Draw lightly, so that any initial, unwanted lines can be erased easily. Your final work could be a detailed pencil drawing, or the pencil lines can be drawn over using a ballpoint, felt-tip or technical pen – or for the complete and authentic manga-style finish, use a waterproof black ink pen. At this point, gently erase the original pencil lines.

If you want to add colour, you could use pencil crayons, markers, watercolours or acrylics. Alternatively, if you have the equipment and the skills, your drawings can be scanned into a computer and then coloured in digitally.

Once you get the hang of it, you may want to try drawing your own creations, using the simple construction method shown here. You can make the process easier if you use tracing paper to transfer shapes and lines to your drawing.

Most importantly, remember to use your imagination: your characters should come with an interesting back-story and a defined personality. Having a clear picture in your mind beforehand of who your characters are is the best way to make your creations authentic and engaging.

*Happy drawing!*

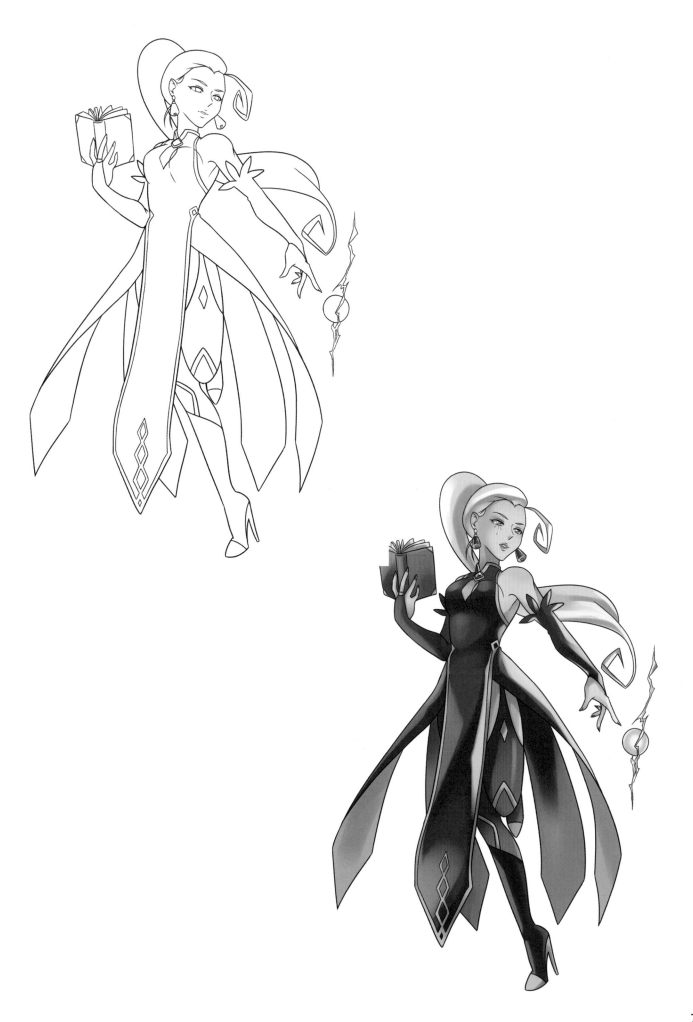

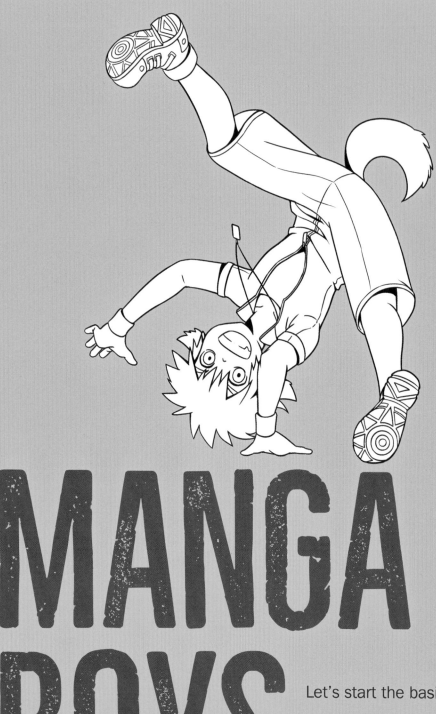

# MANGA BOYS

Let's start the basics of manga drawing with boys. Draw a fantastic selection of male figures – human and the more magical – with a variety of poses and expressions.

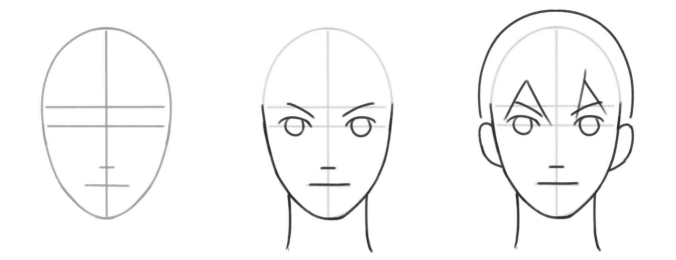

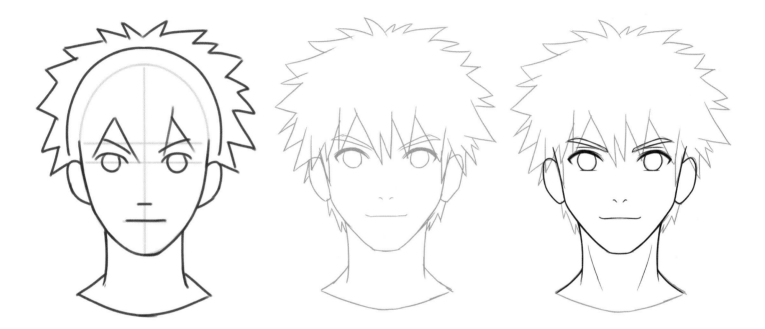

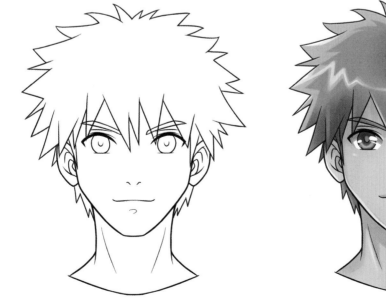

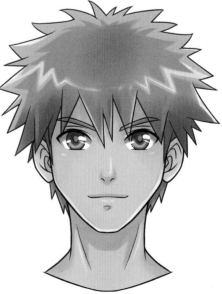

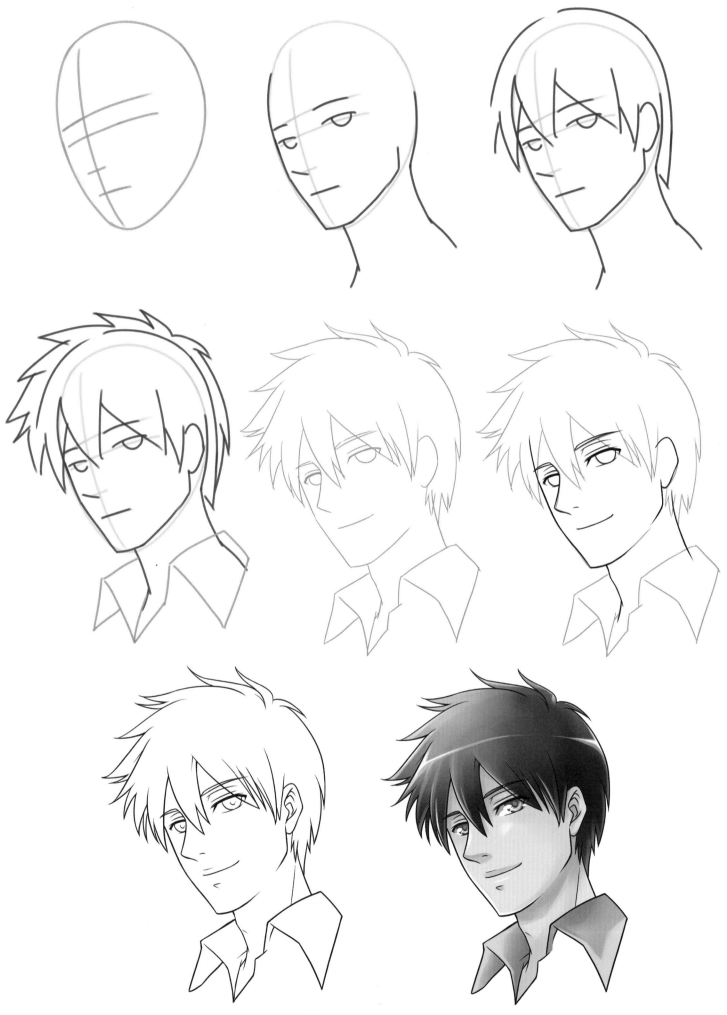

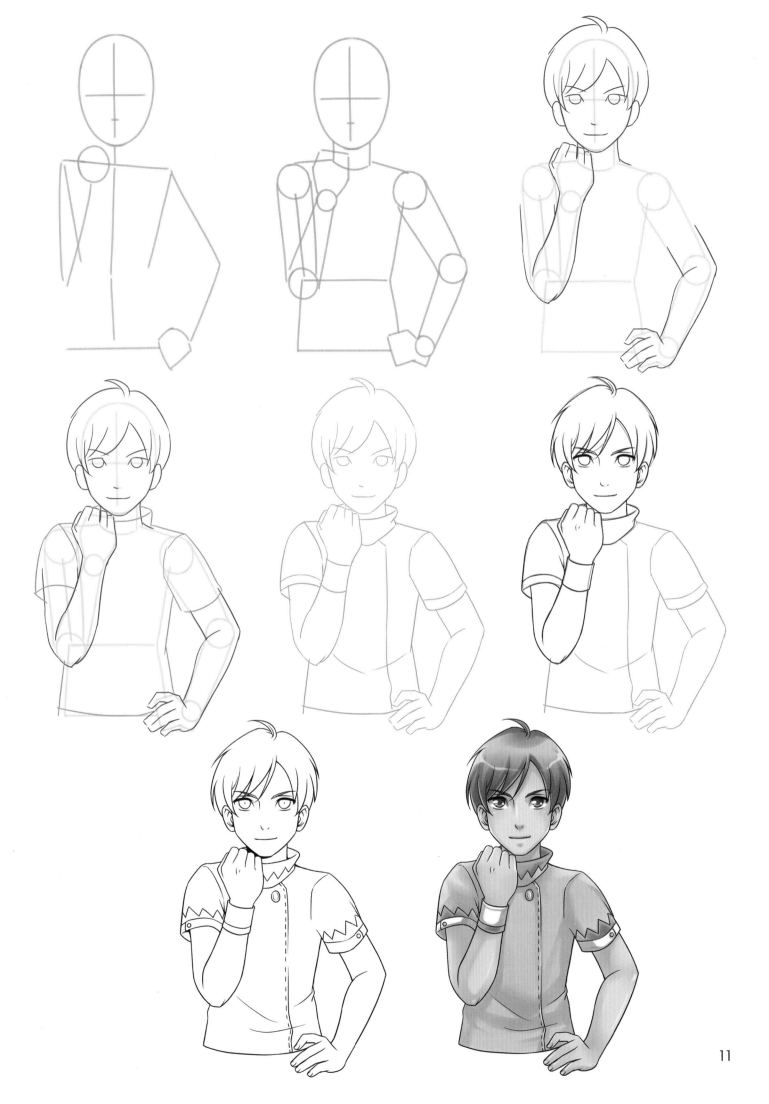

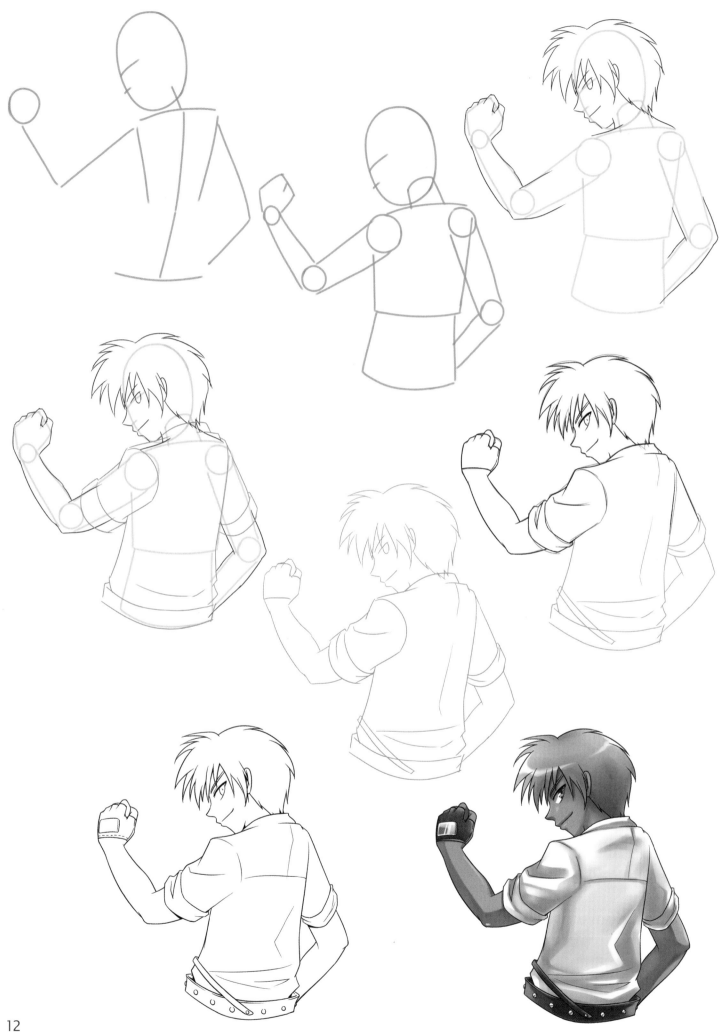

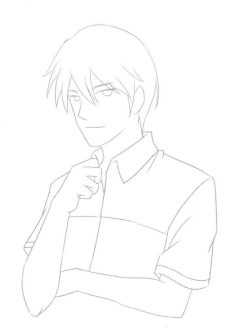

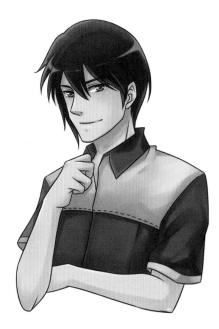

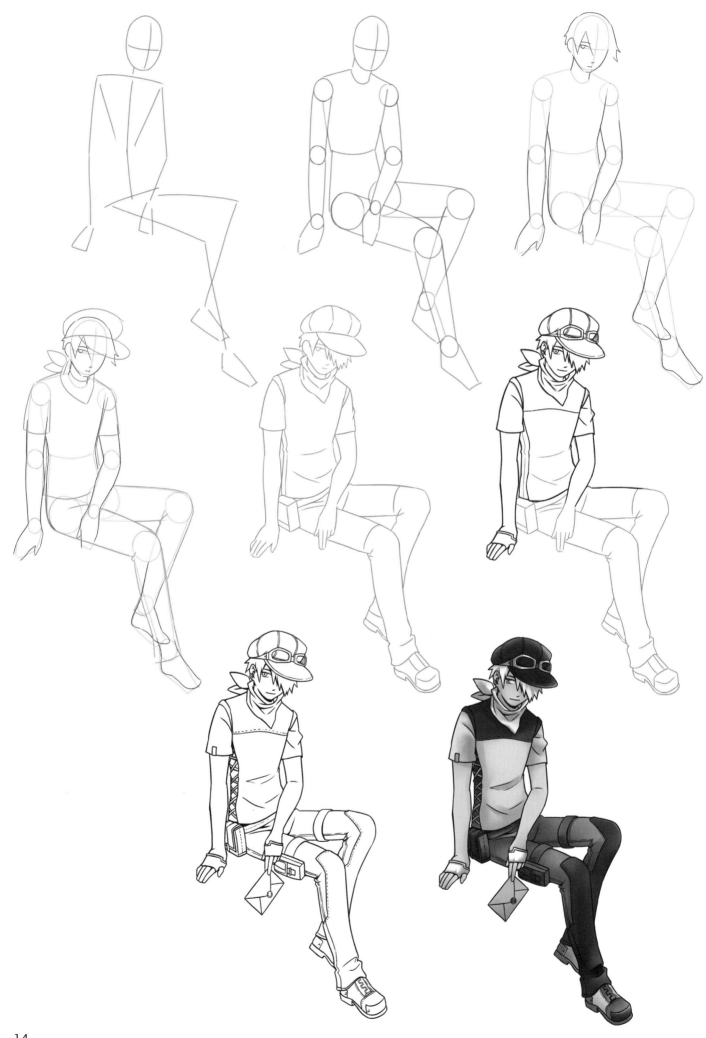

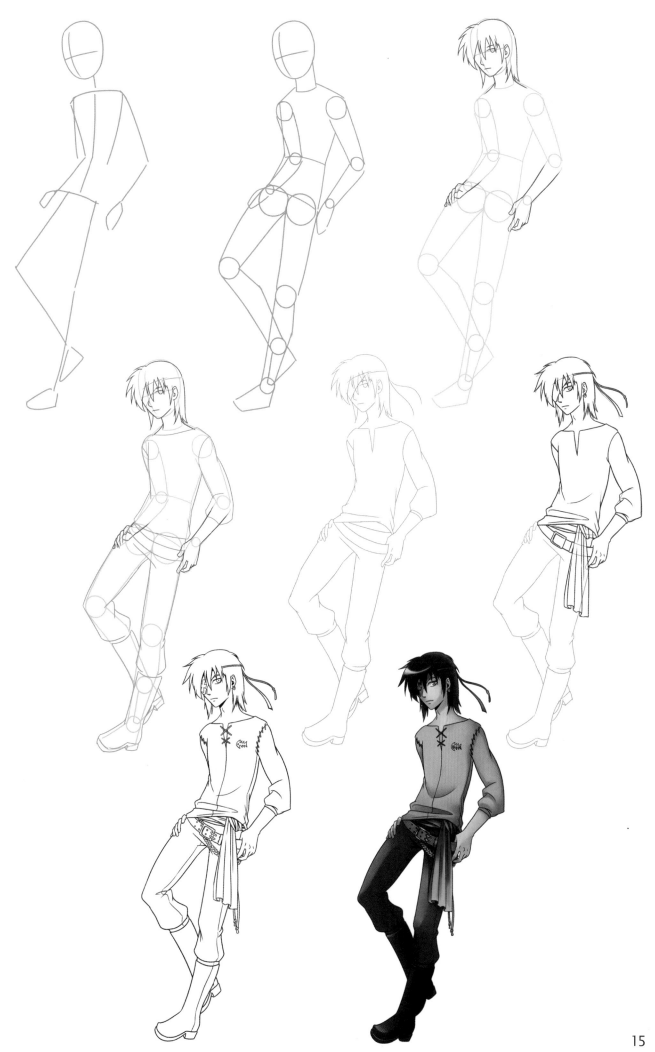

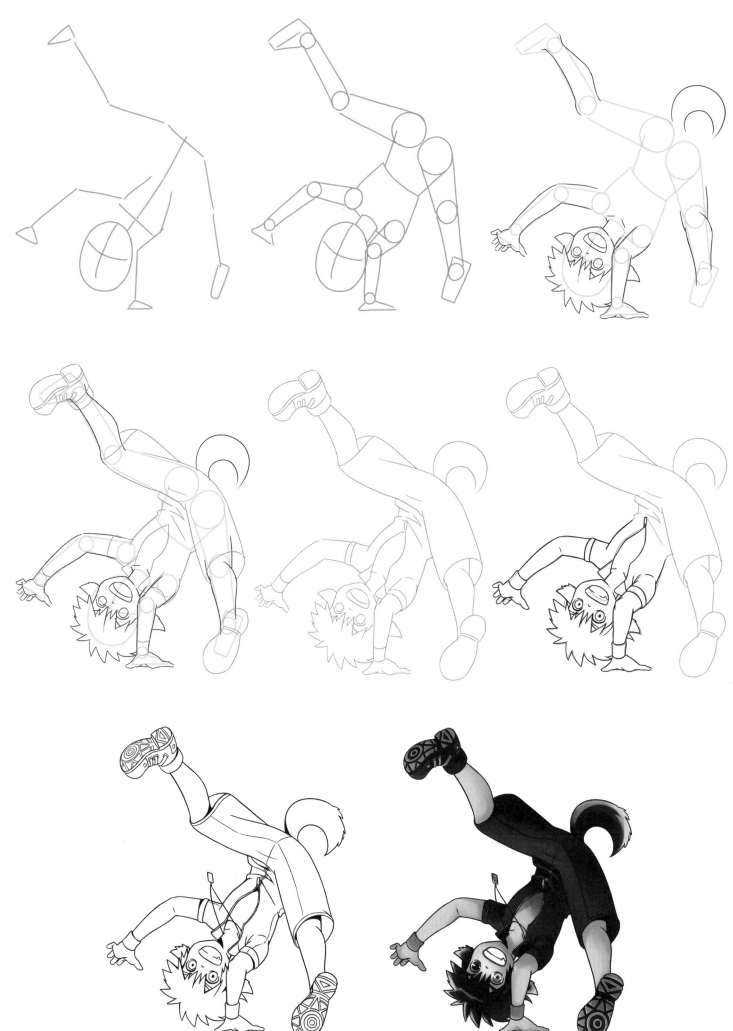

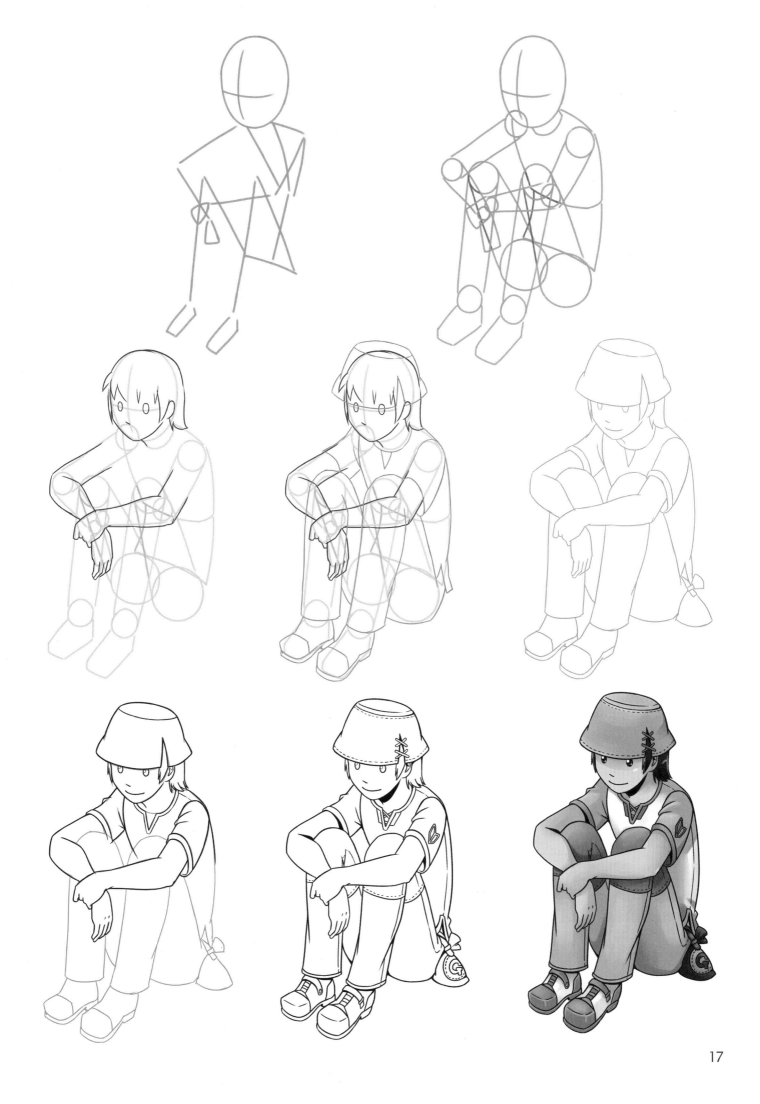

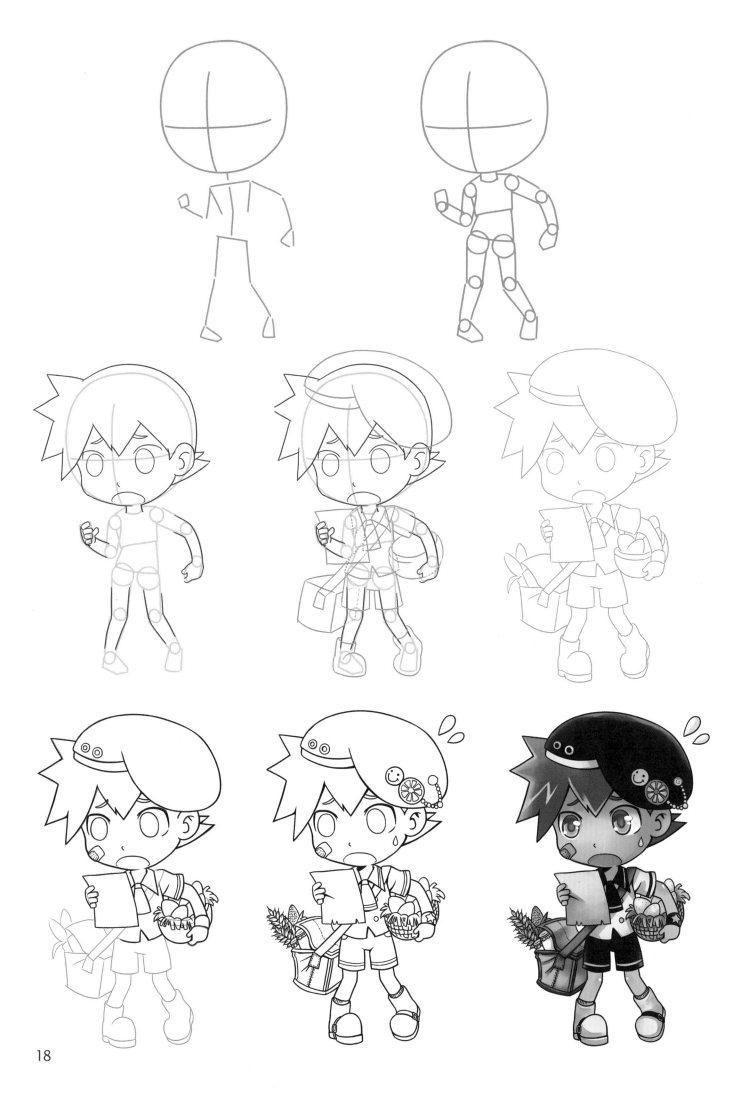

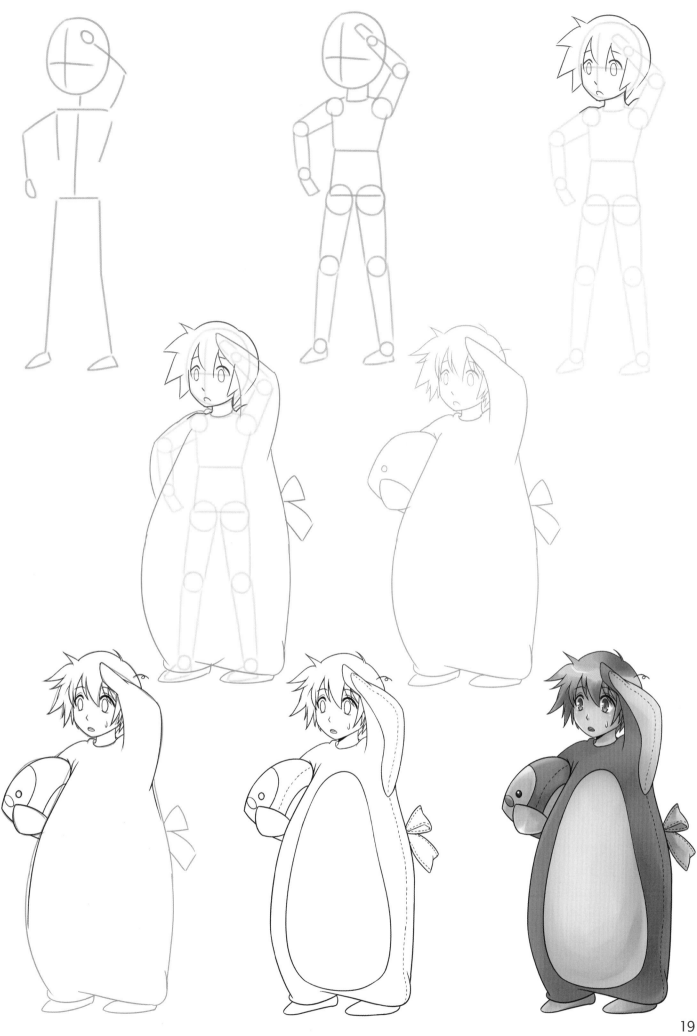

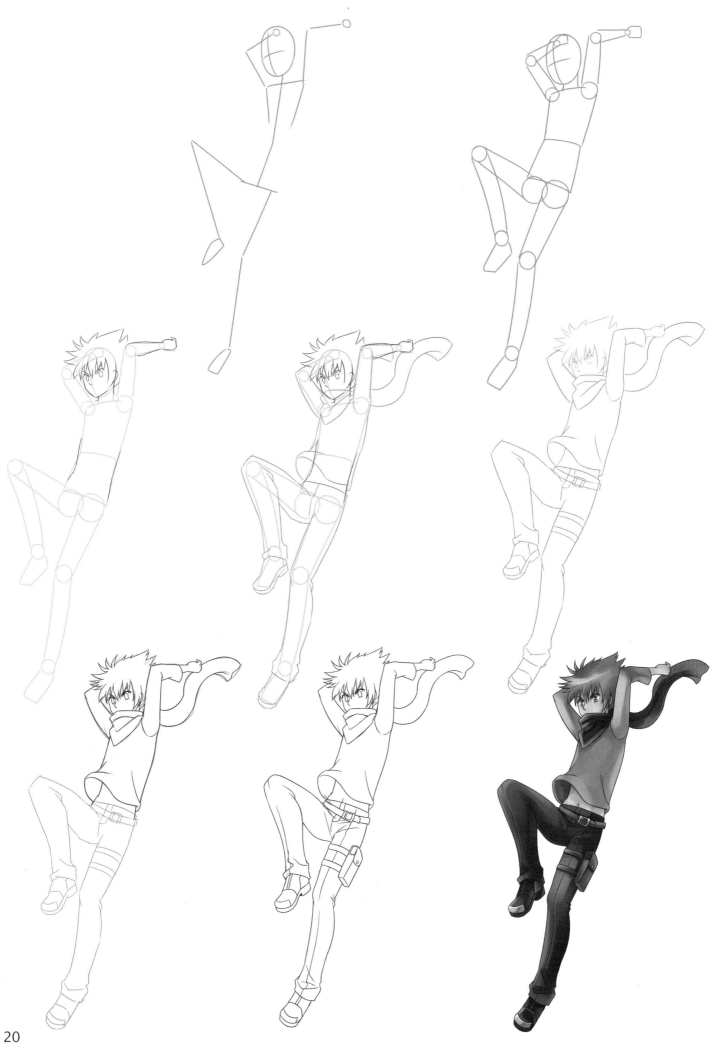

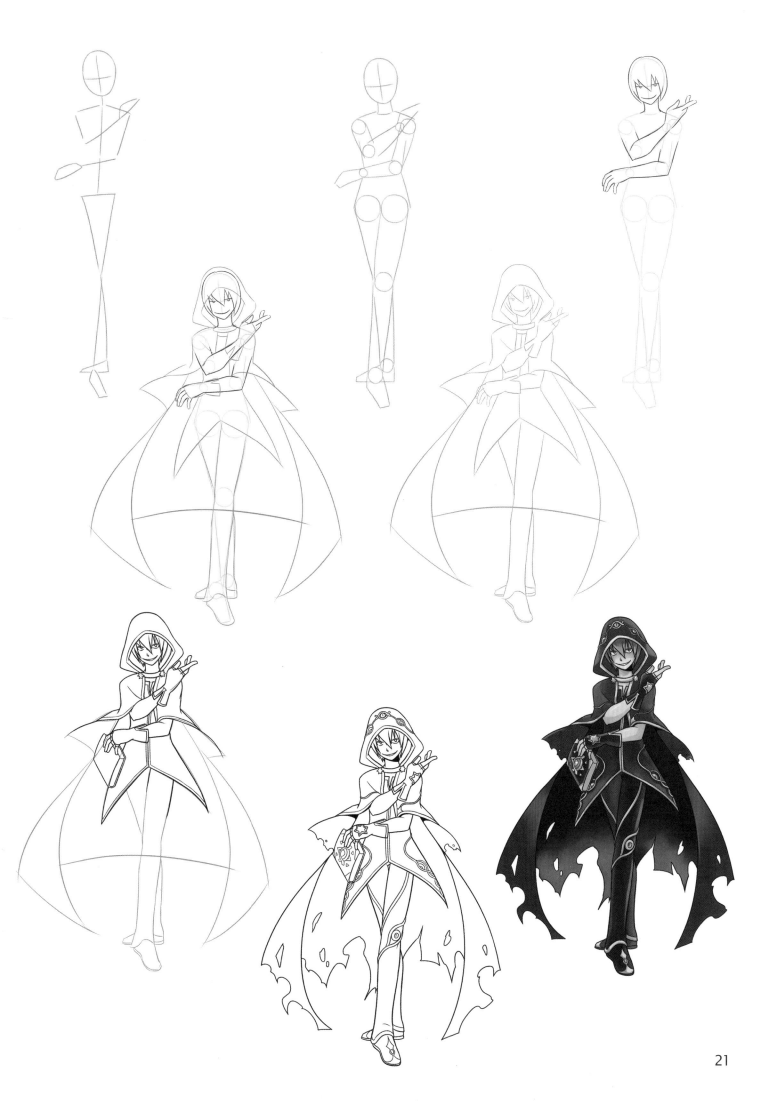

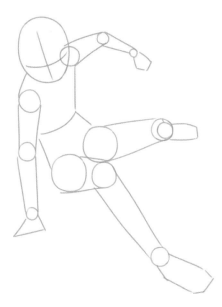
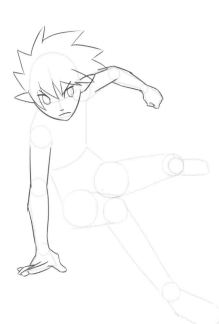
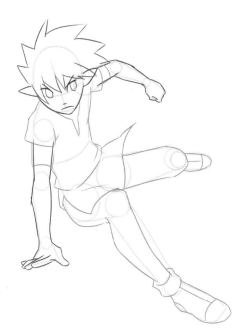
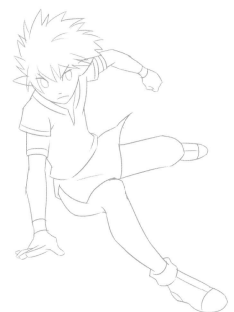
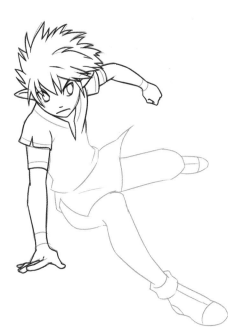
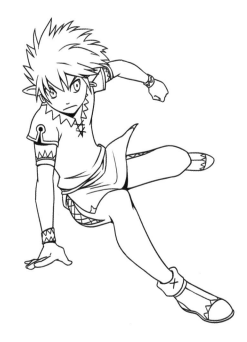
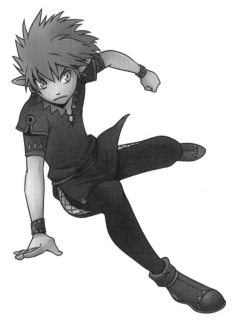

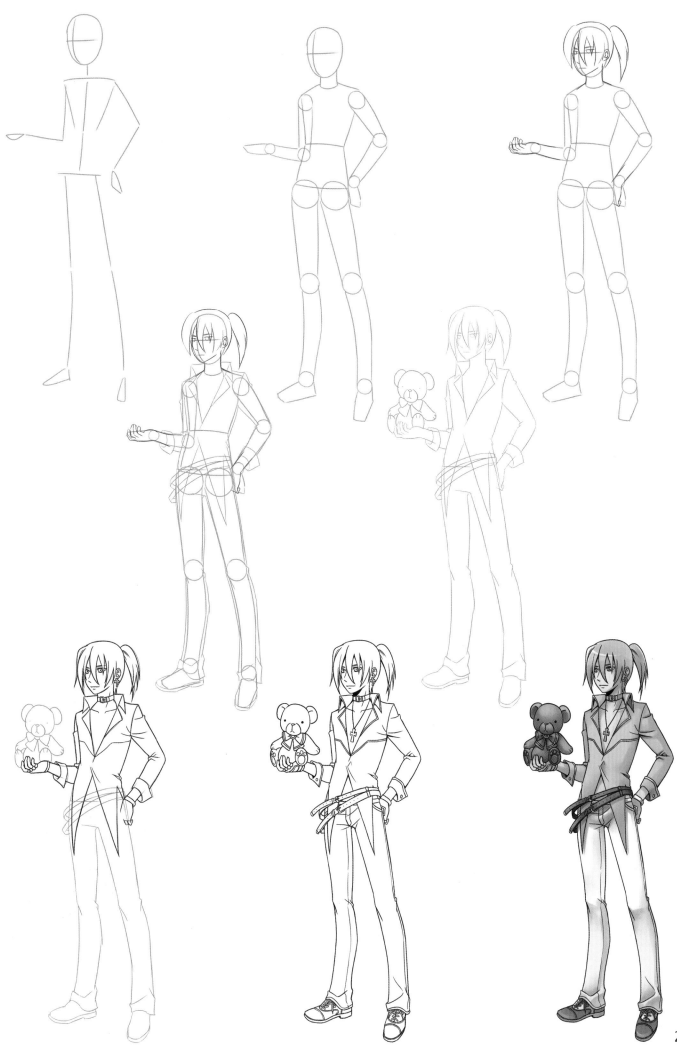

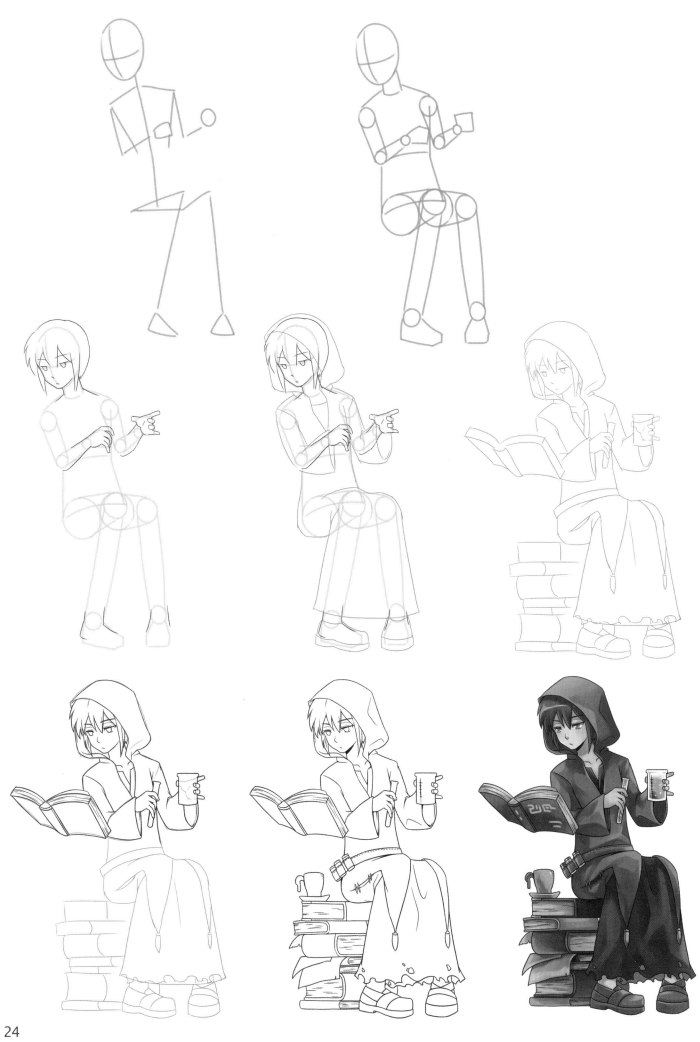

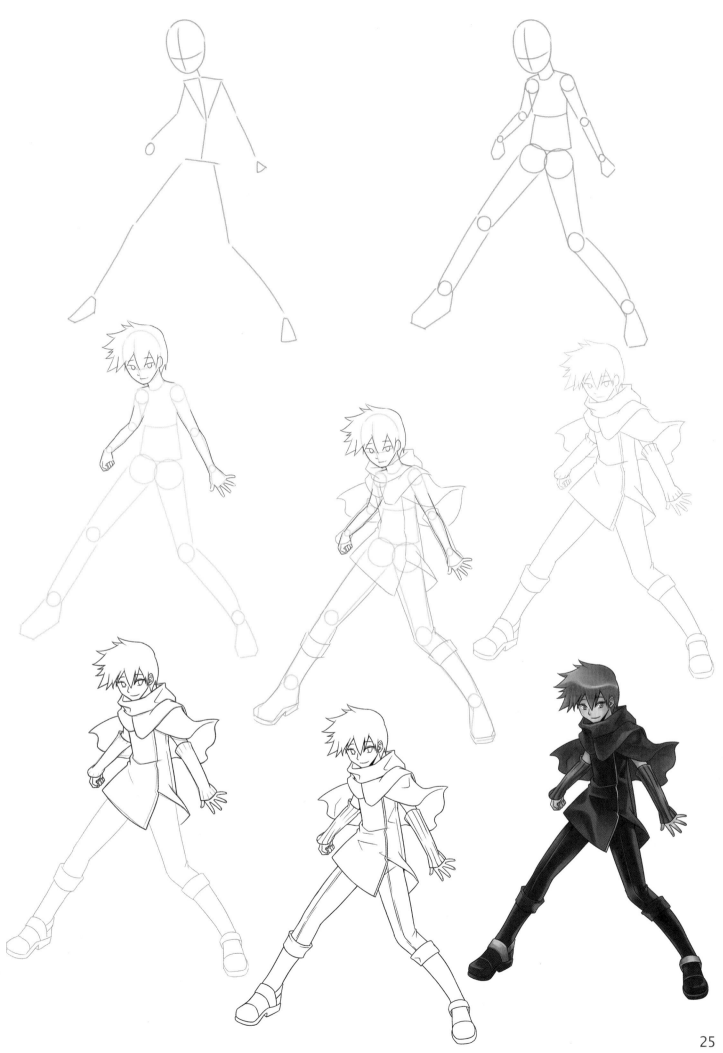

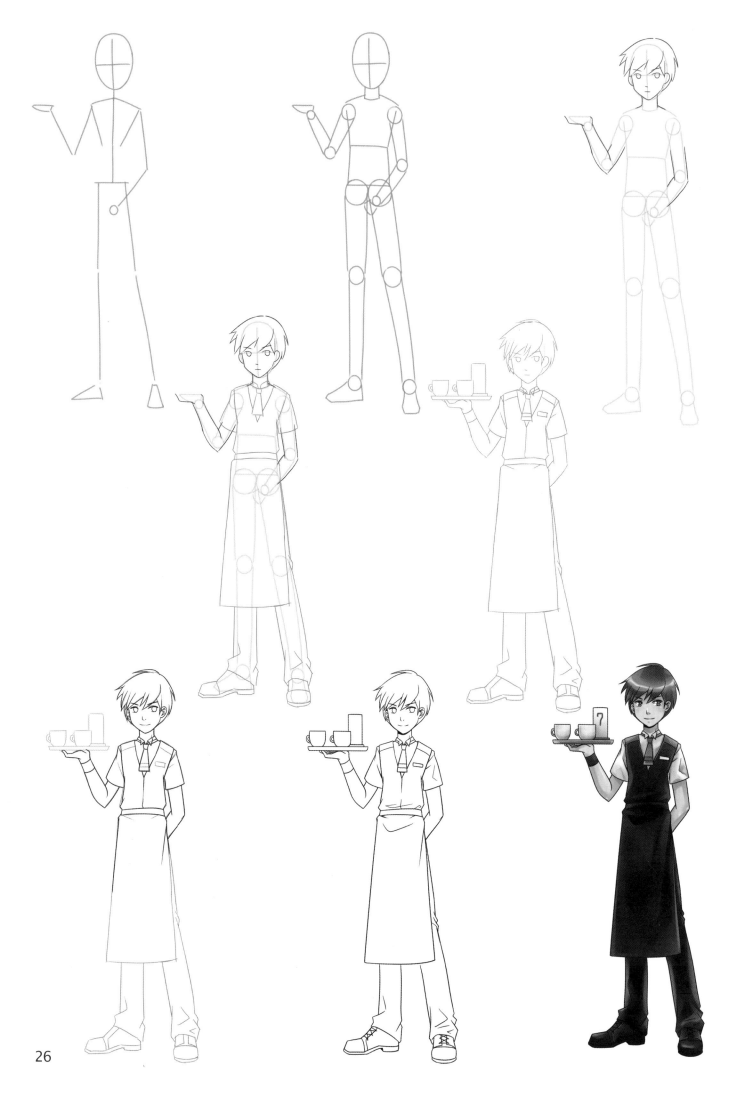

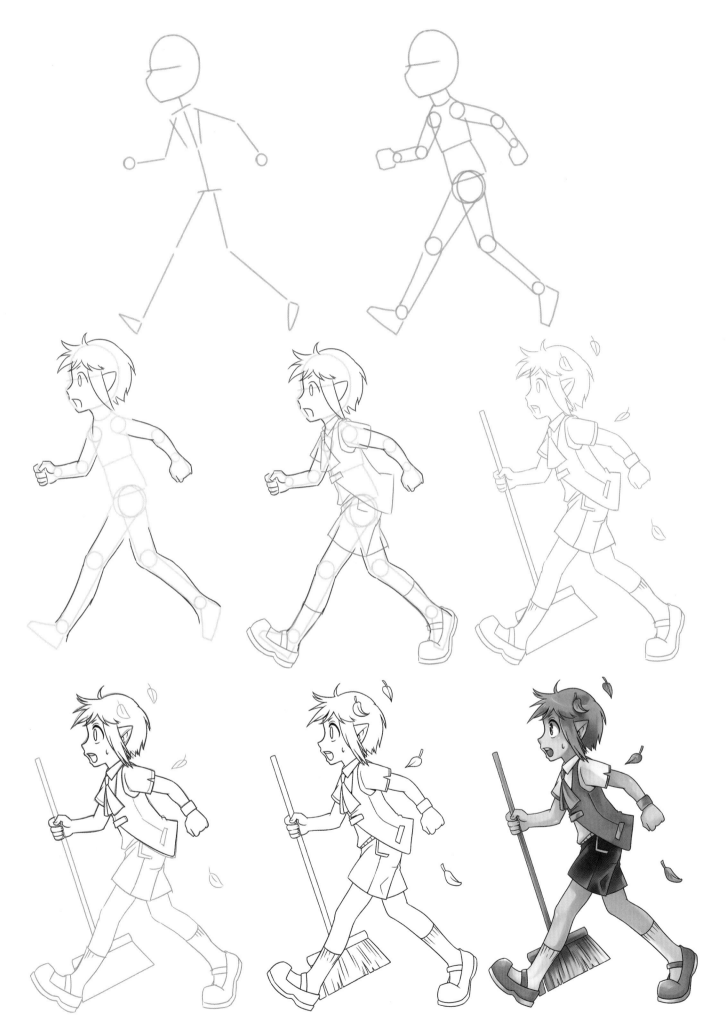

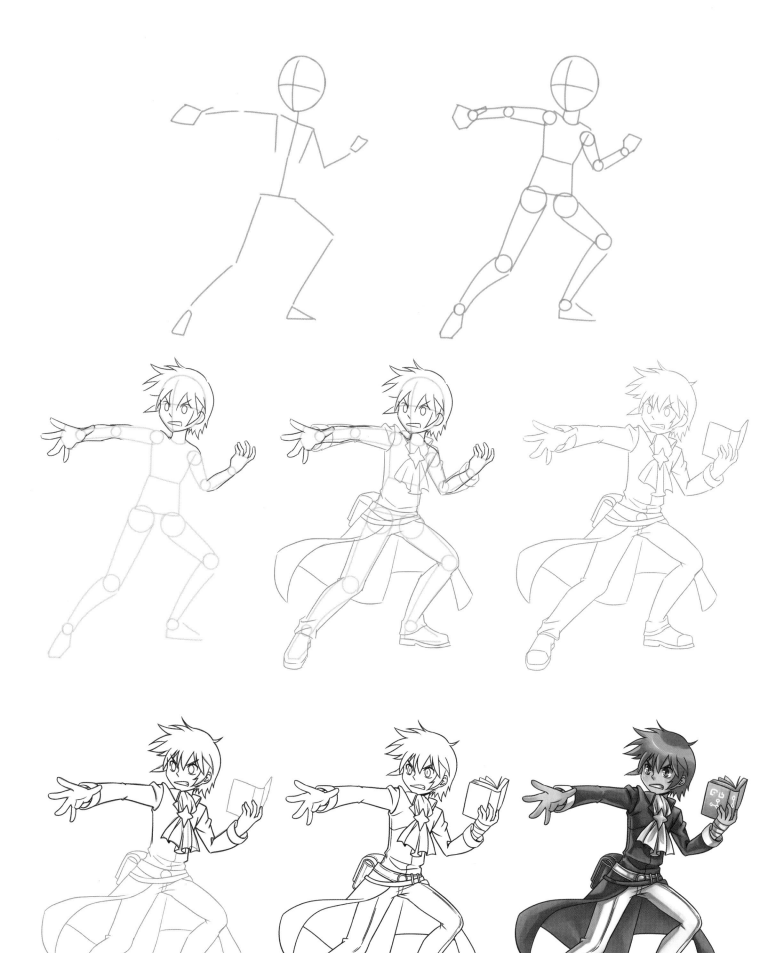

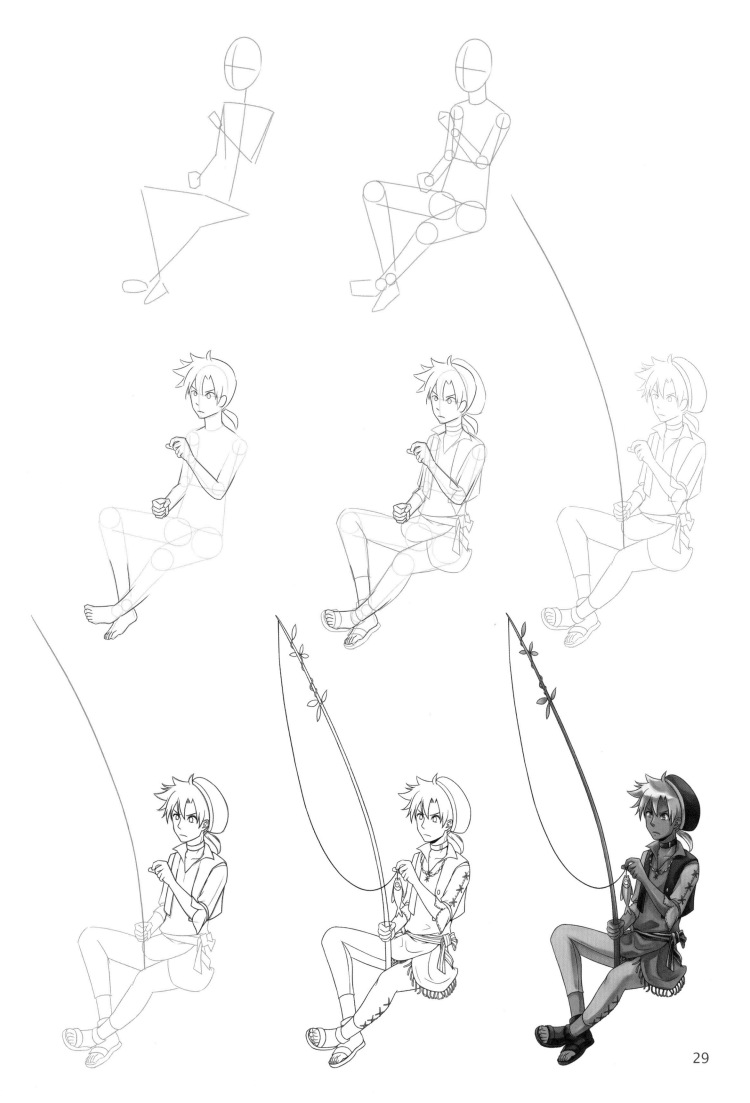

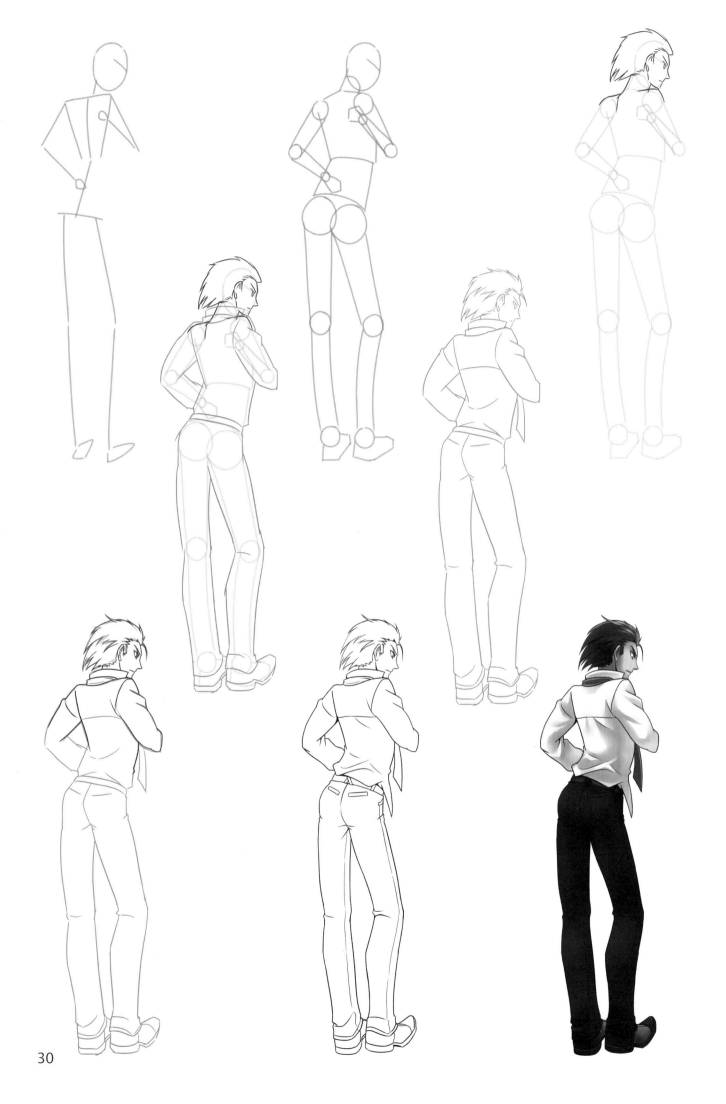

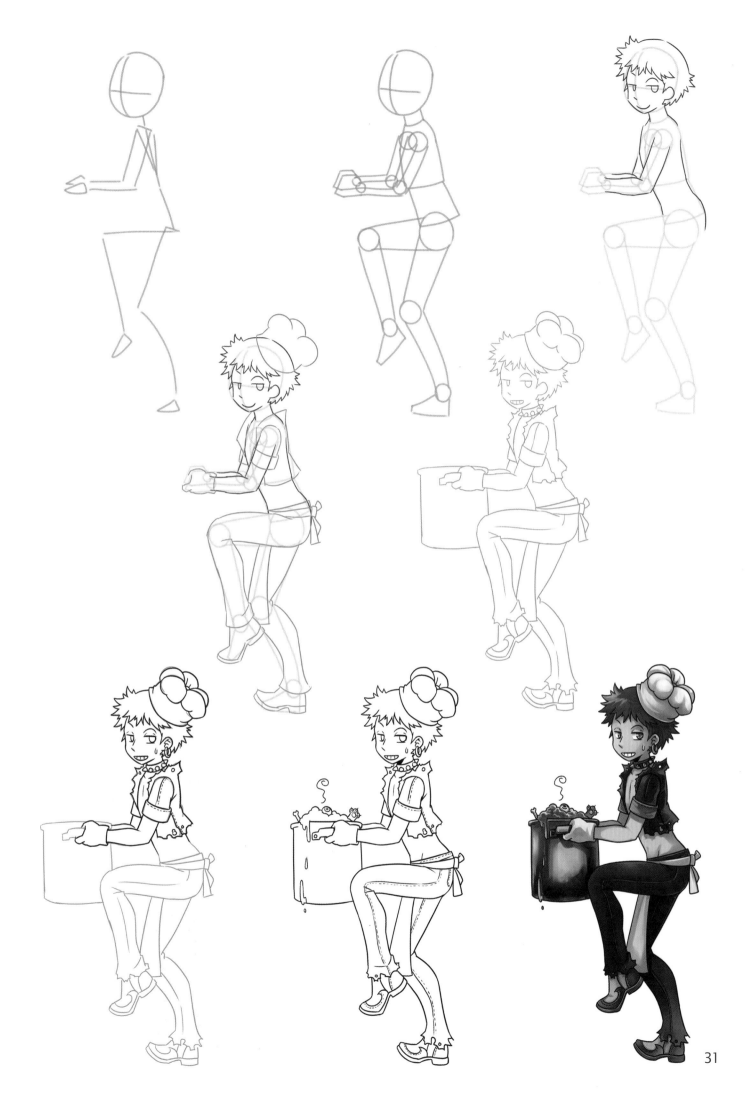

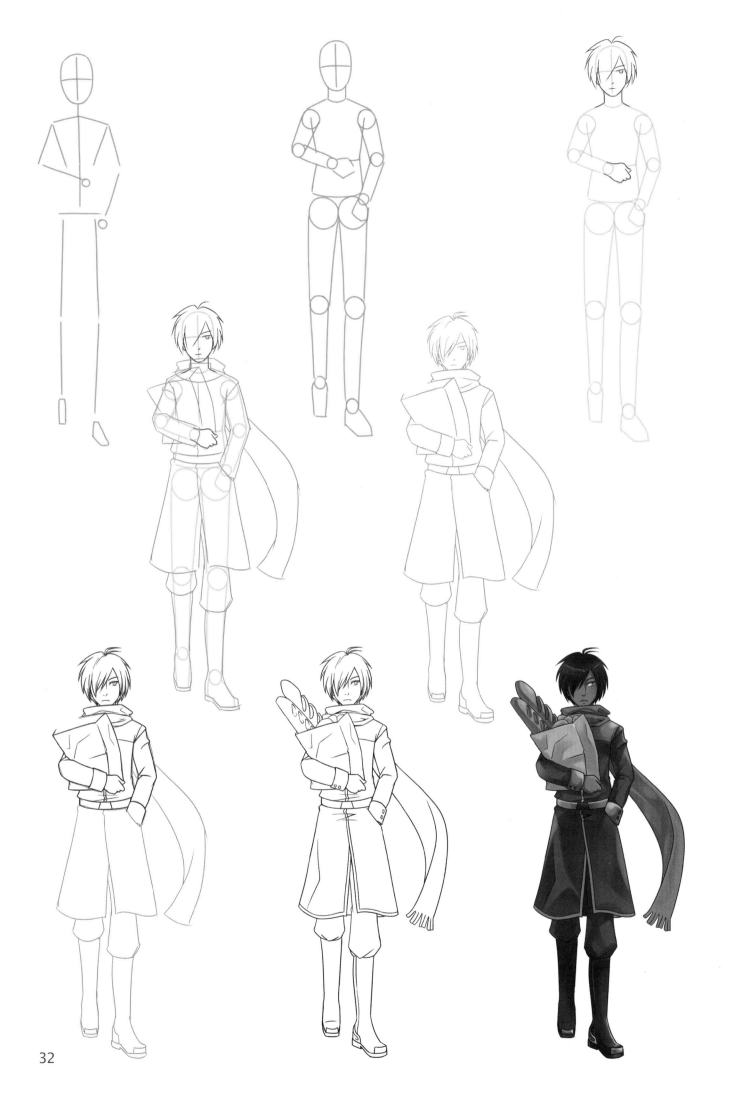

32

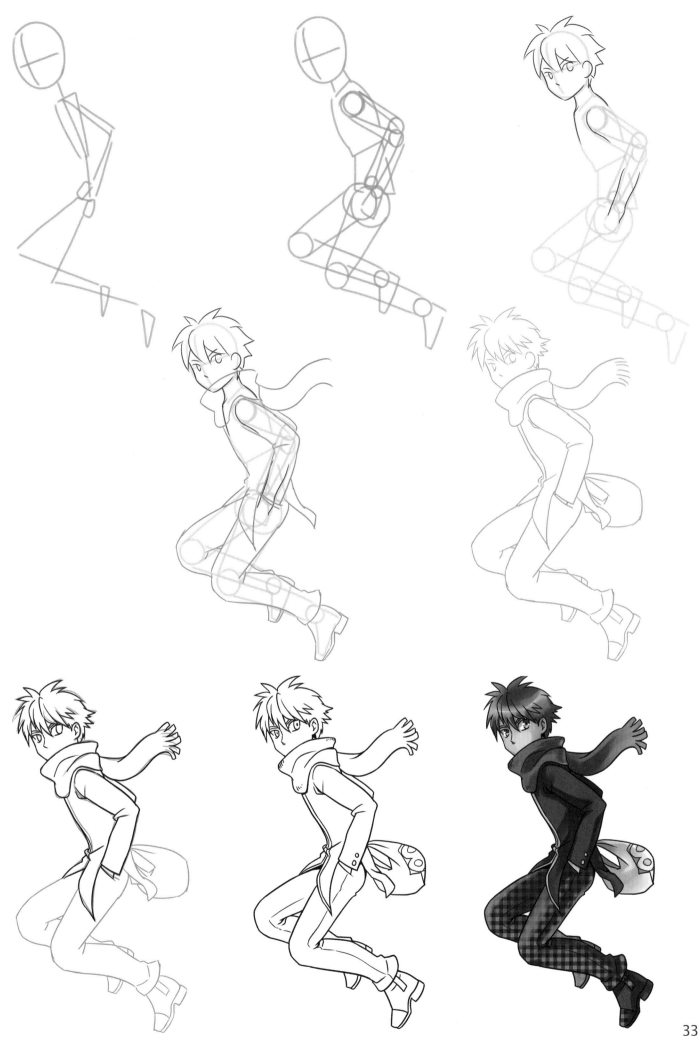

33

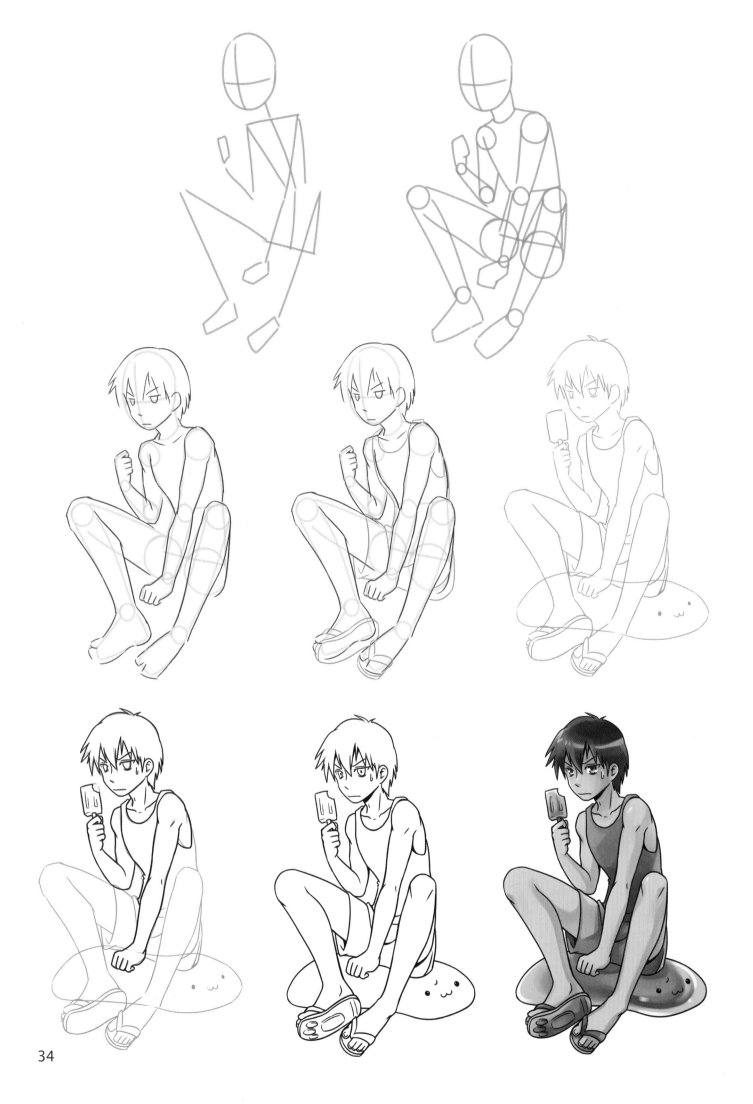

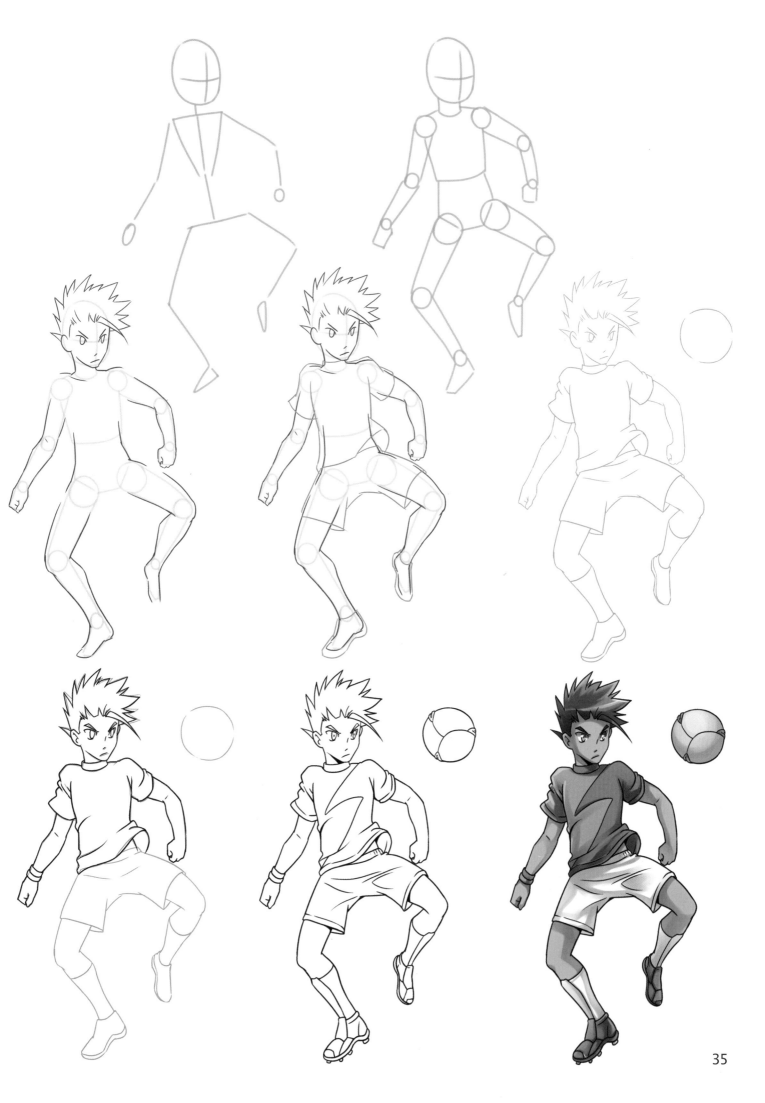

# MANGA GIRLS

Now let's take a look at the girls! Learn to draw ordinary and extraordinary females in the manga style with a number of poses and expressions.

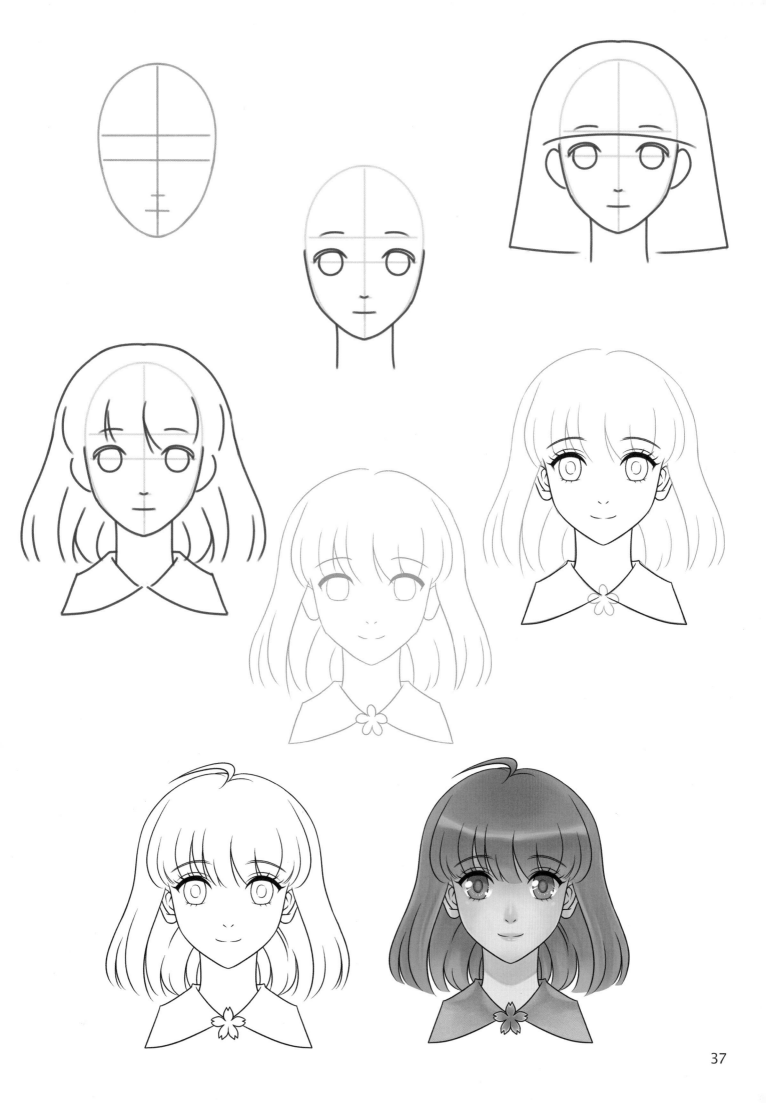

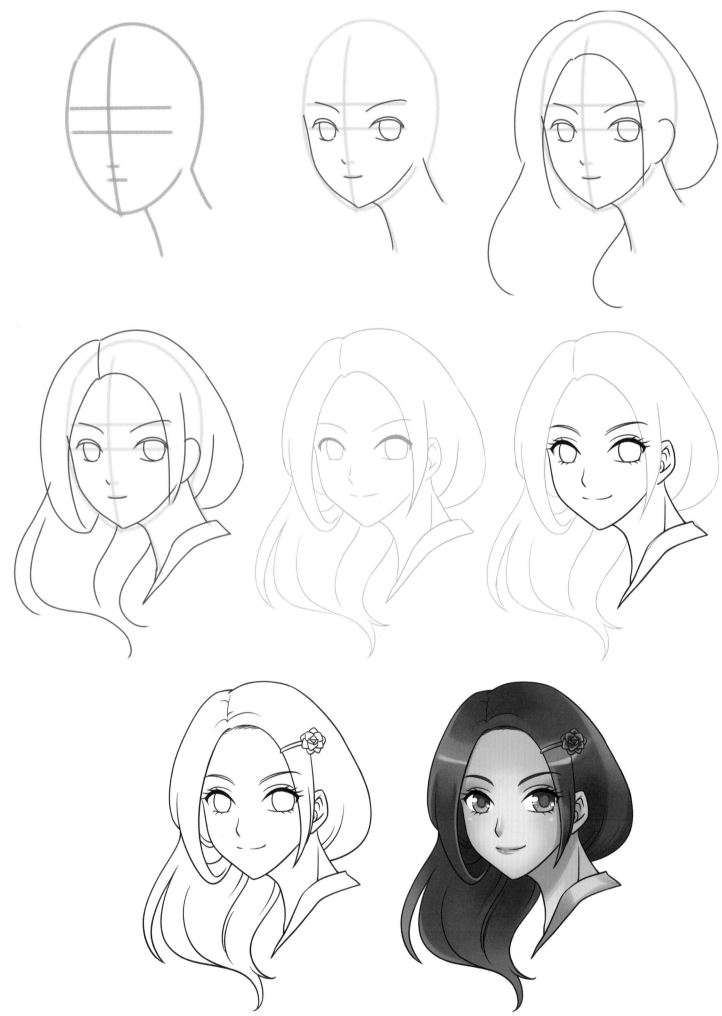

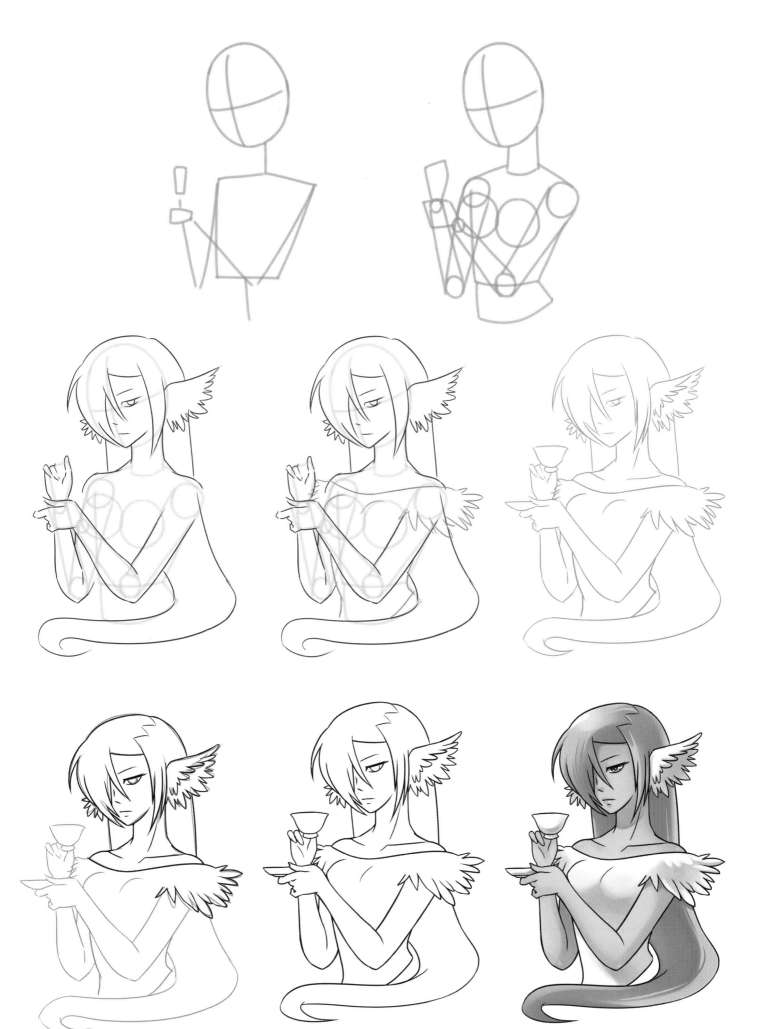

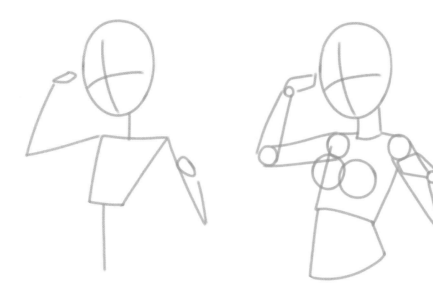

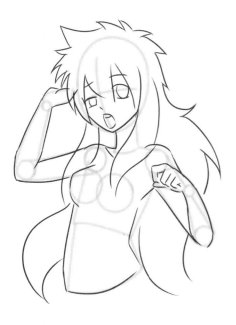

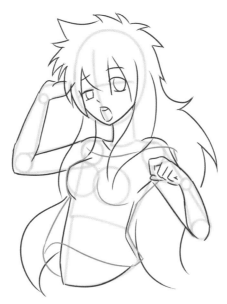

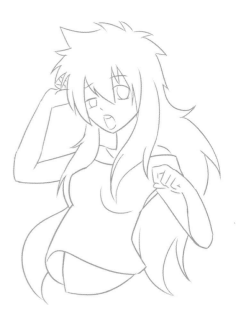

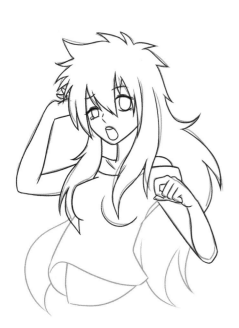

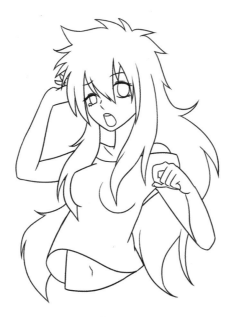

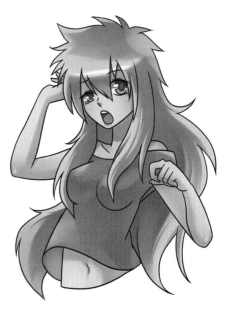

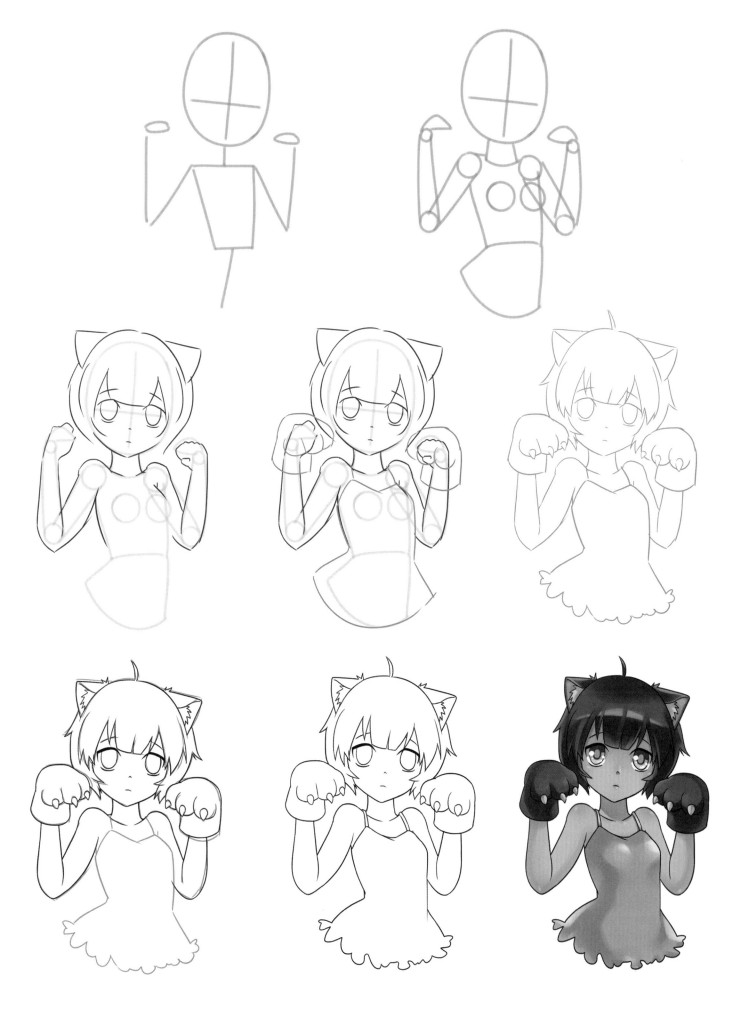

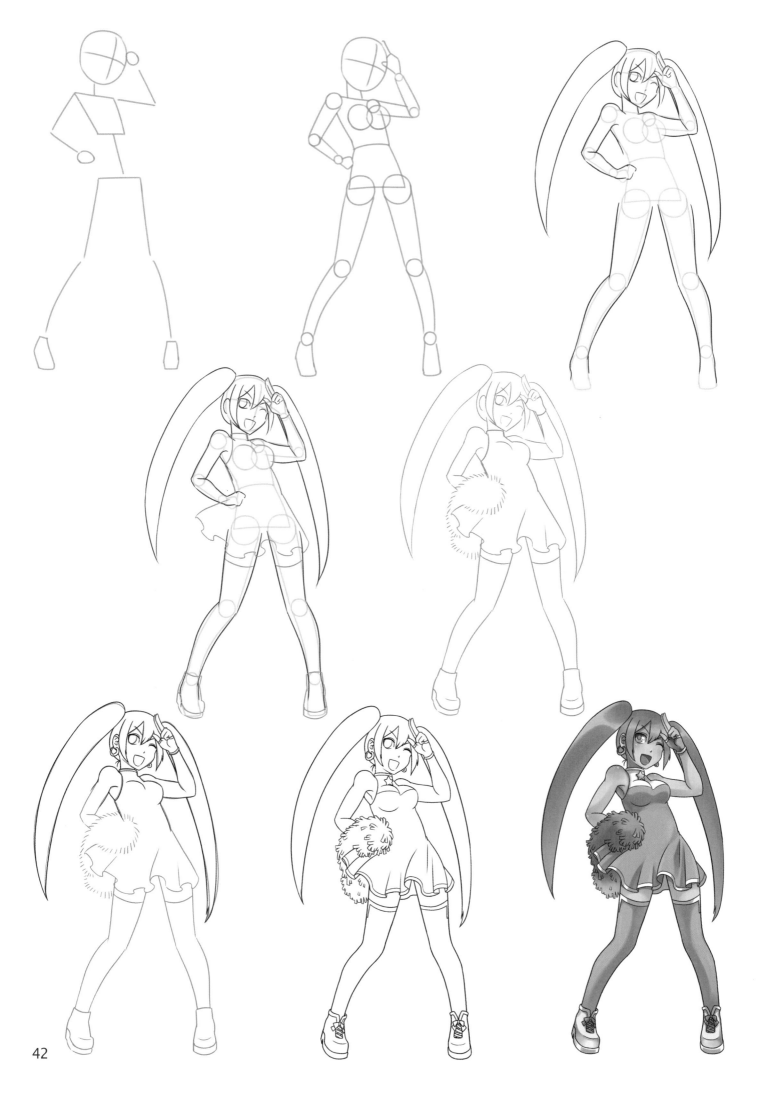

42

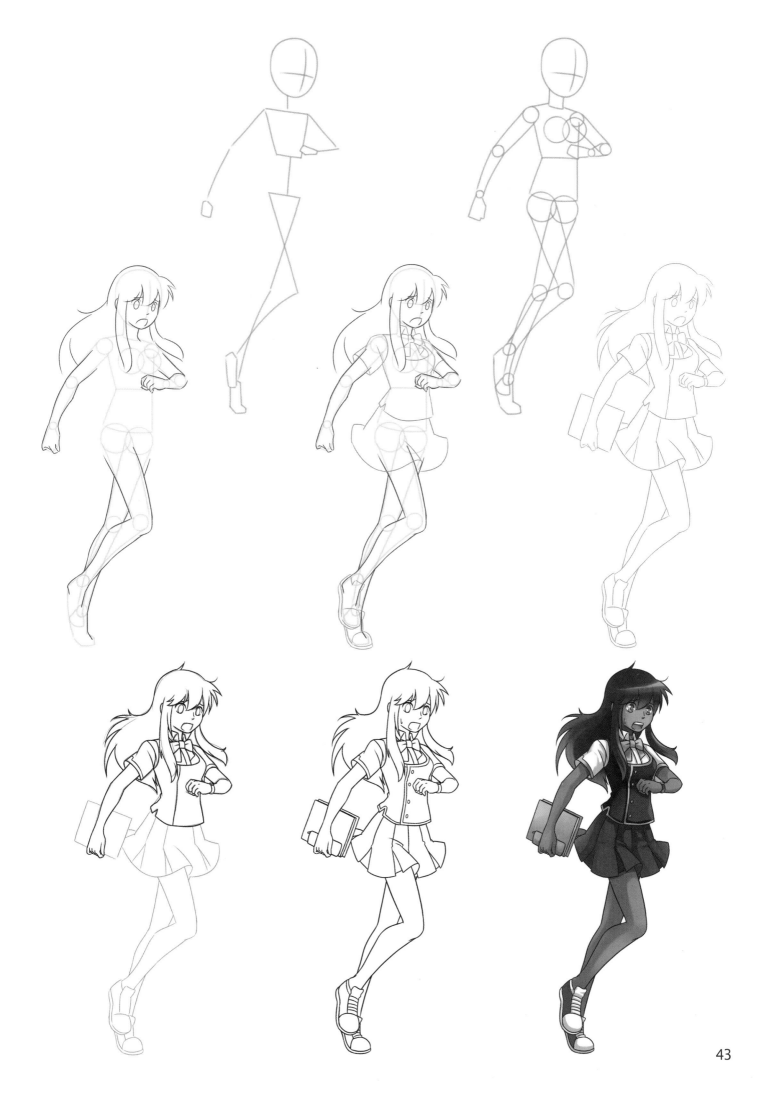

43

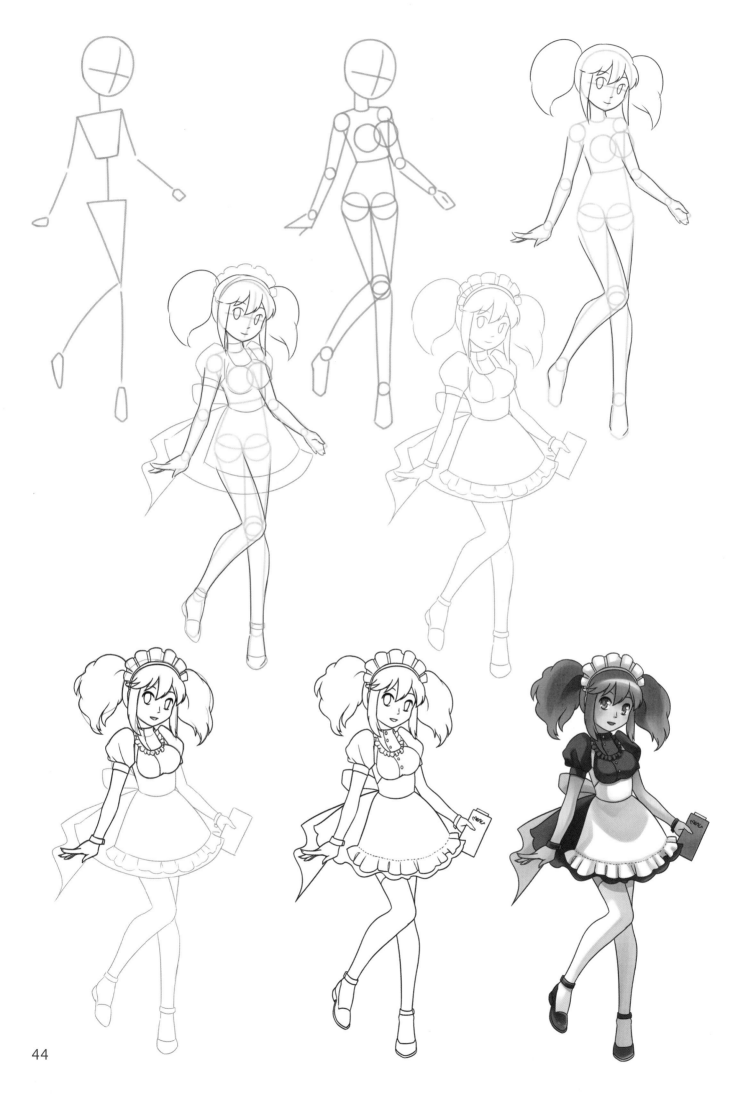

44

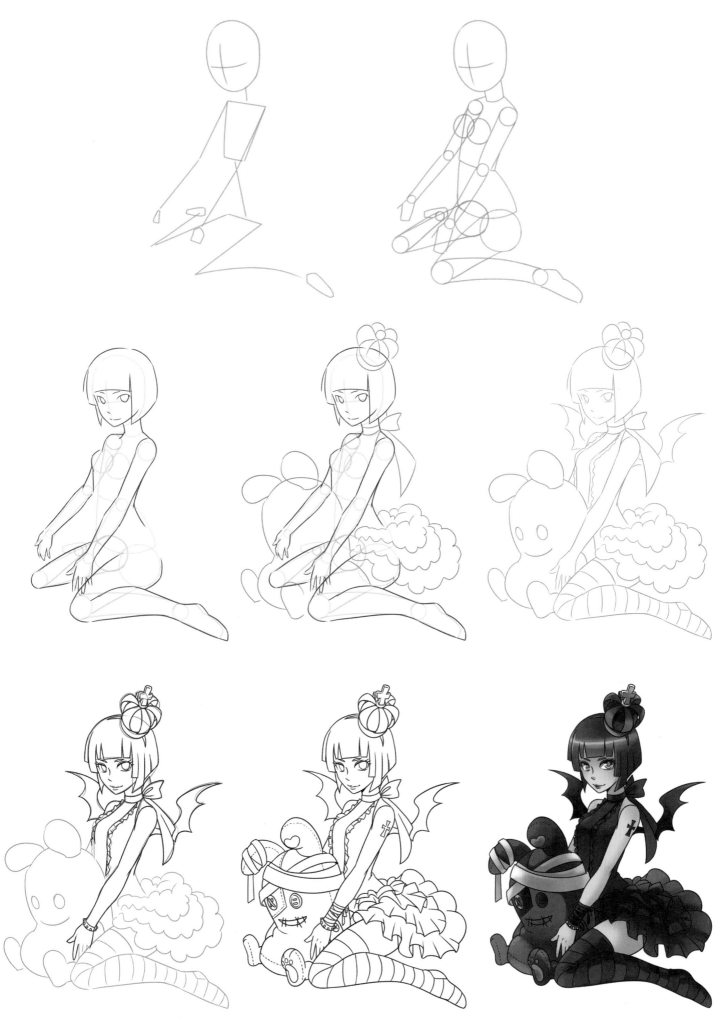

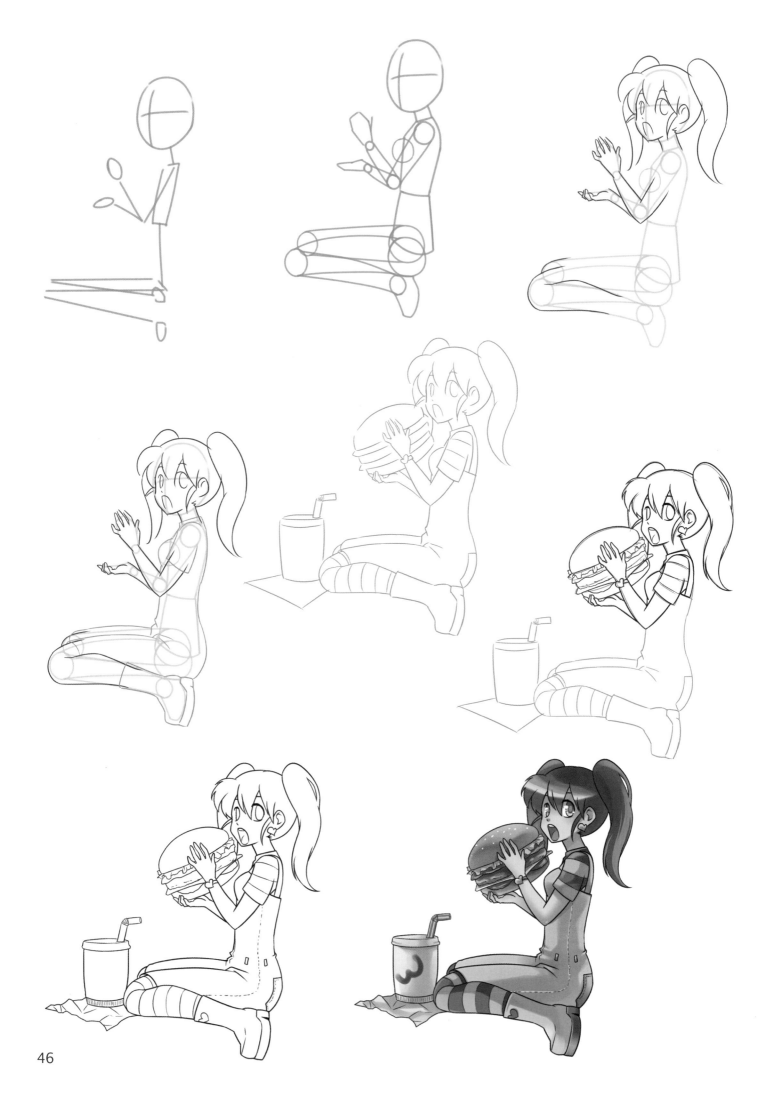

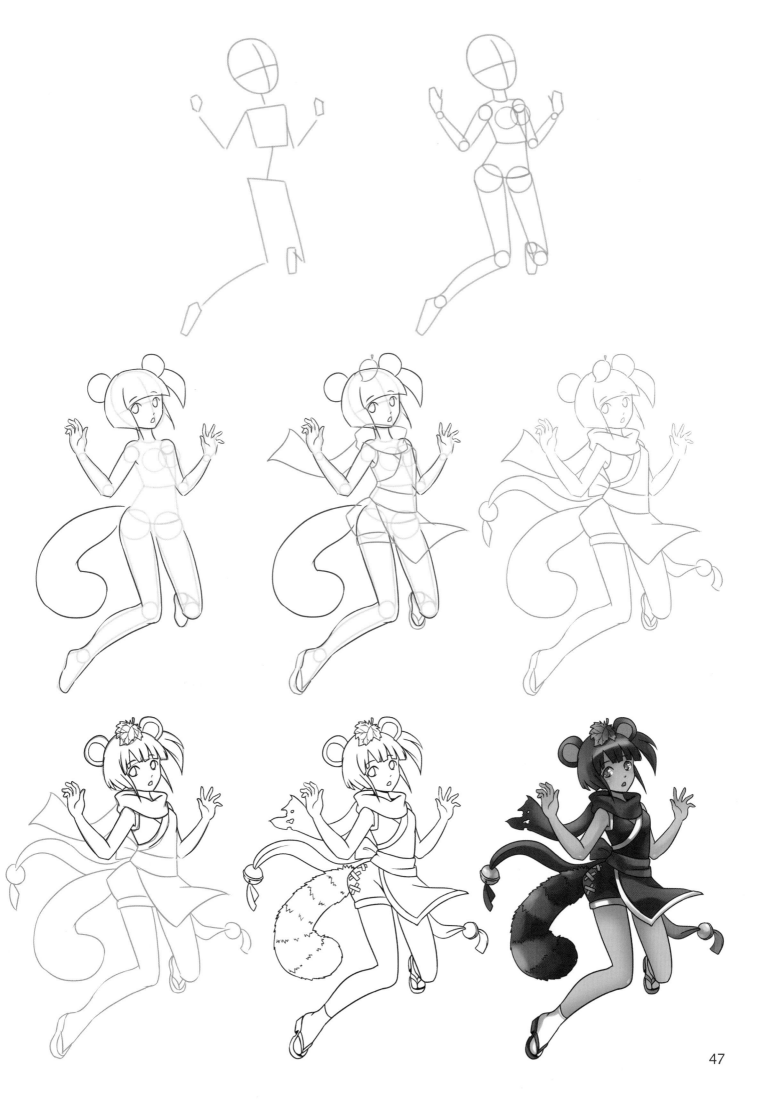

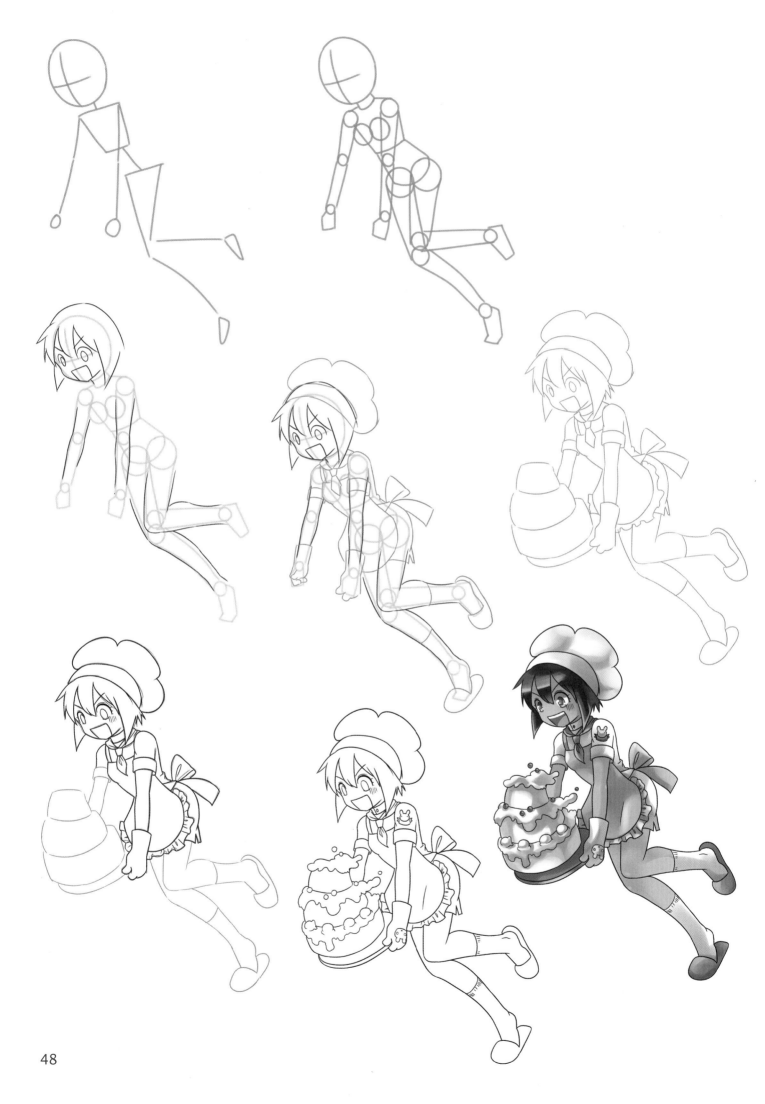

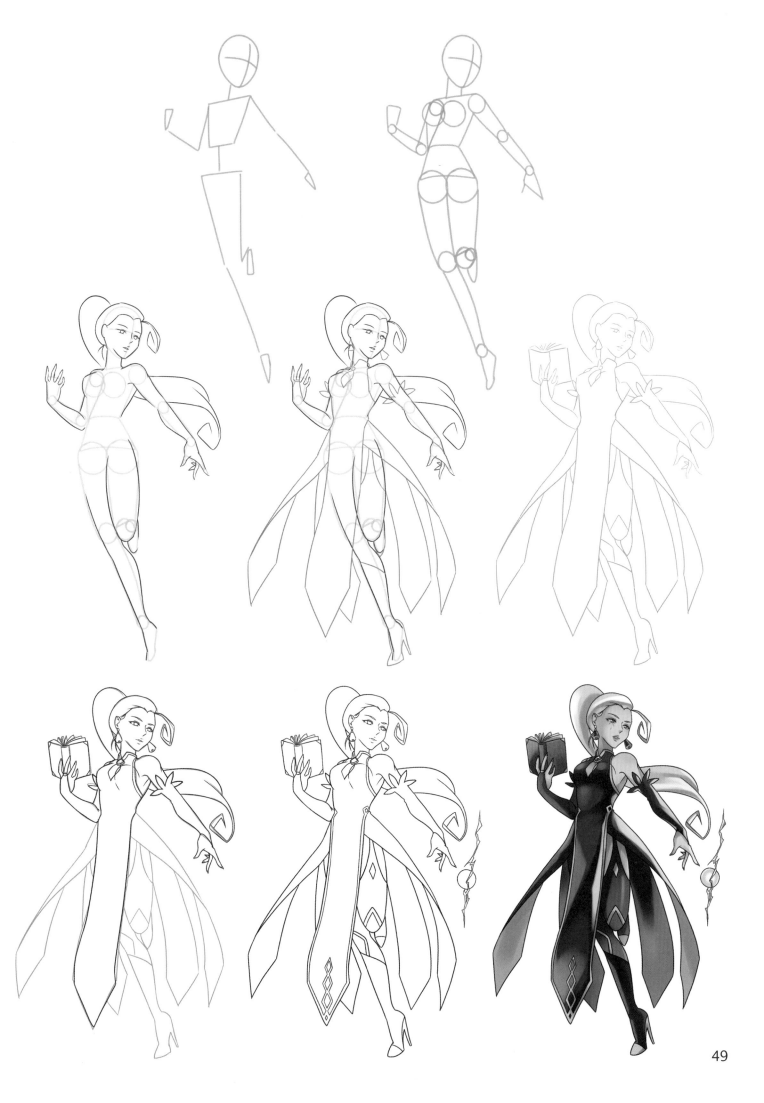

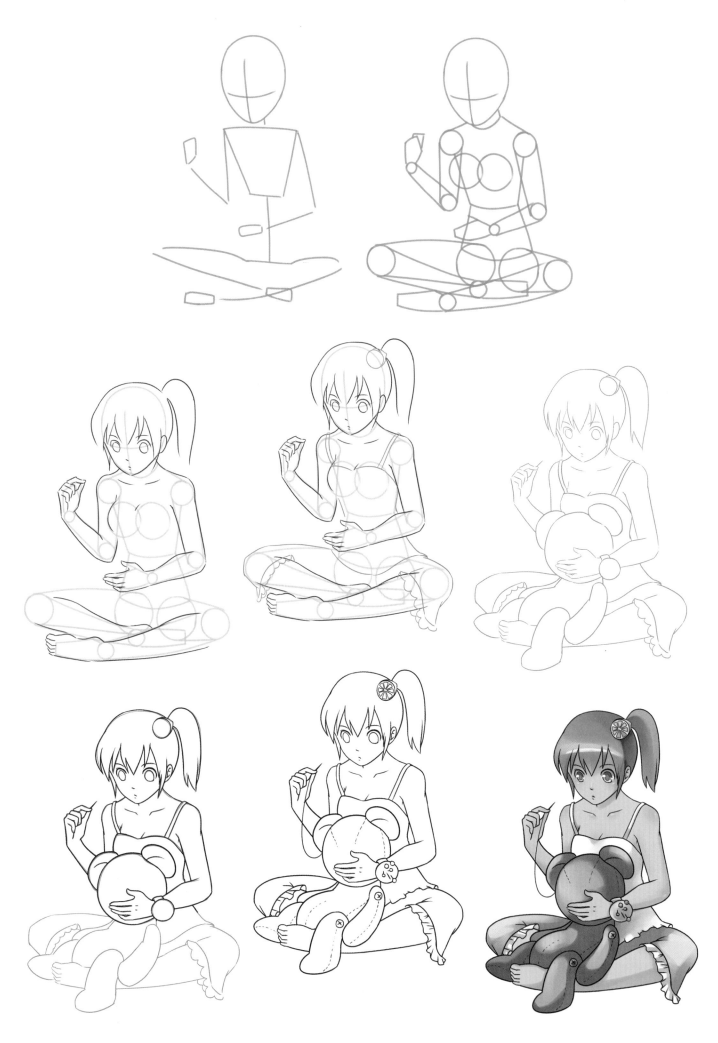

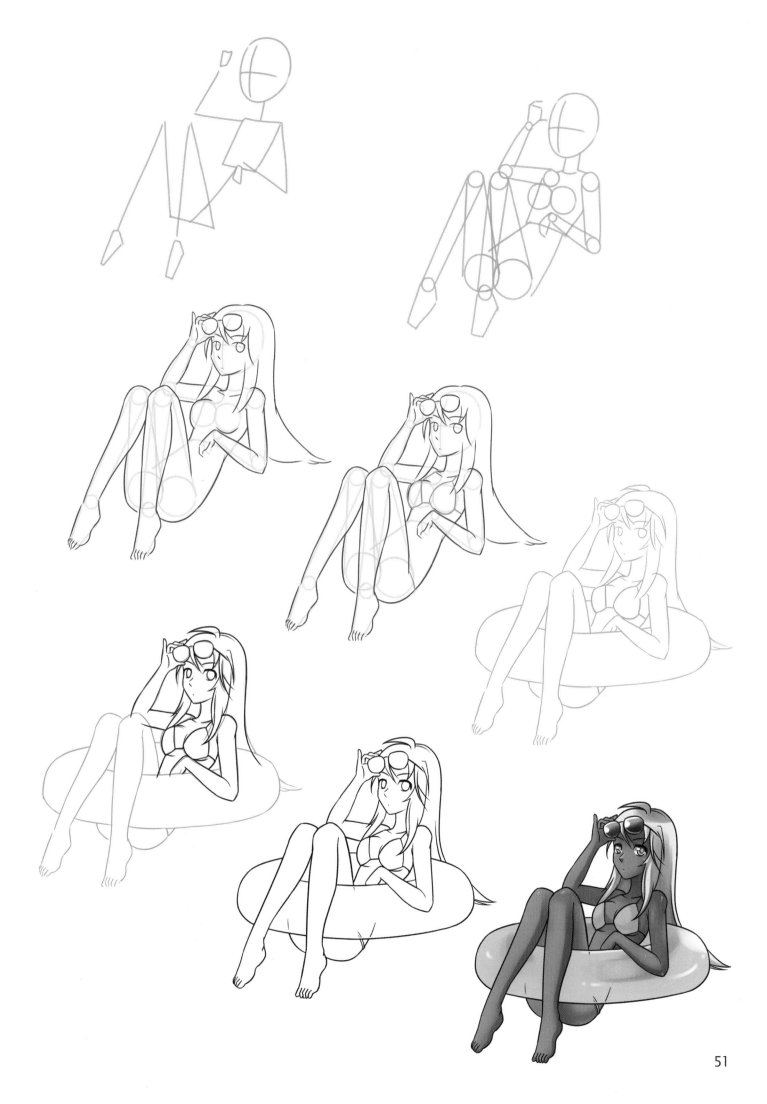

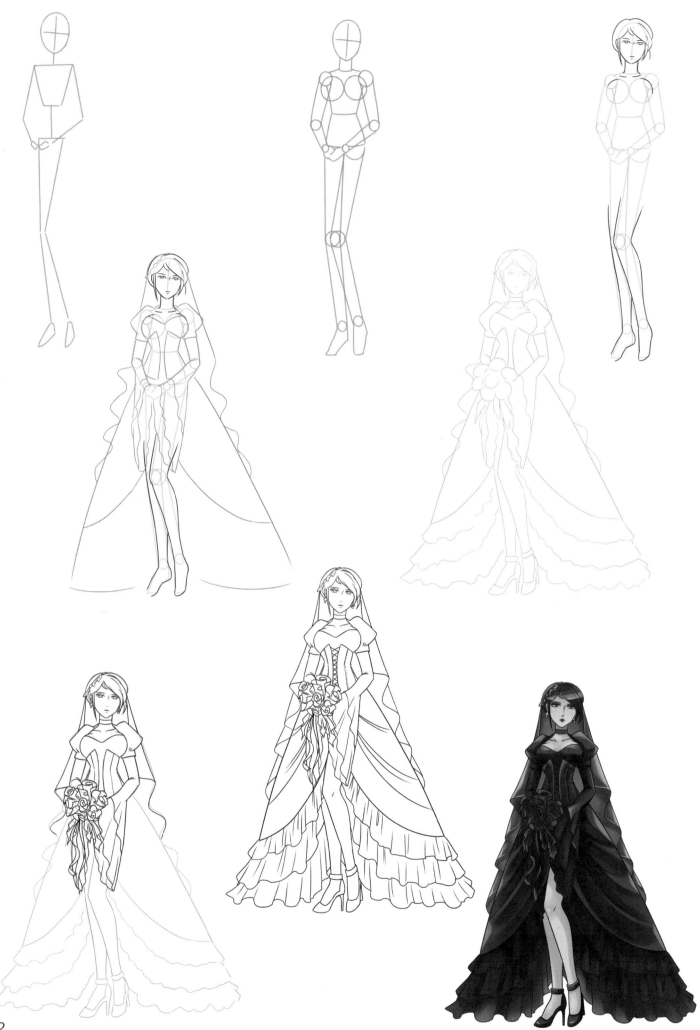

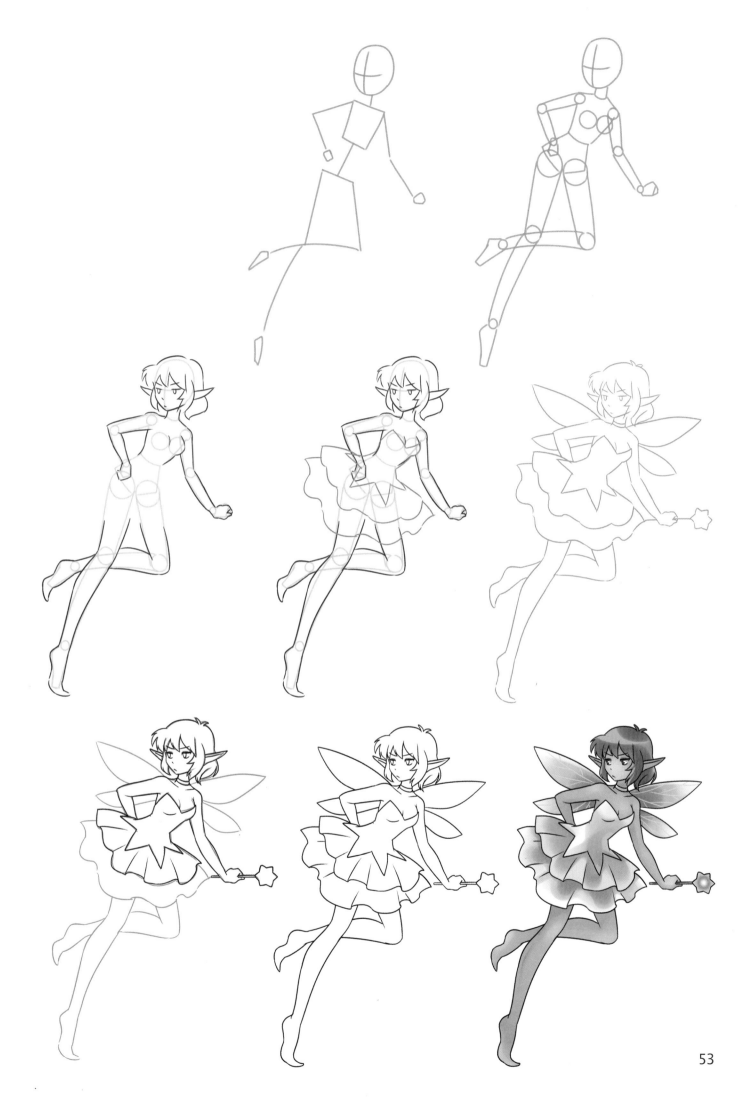

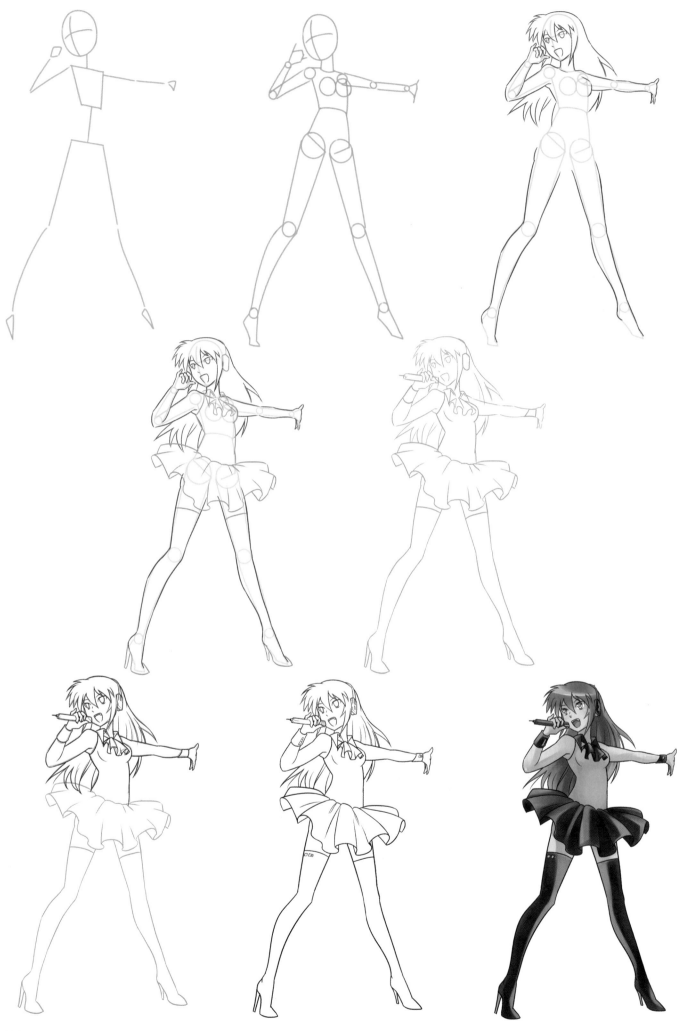

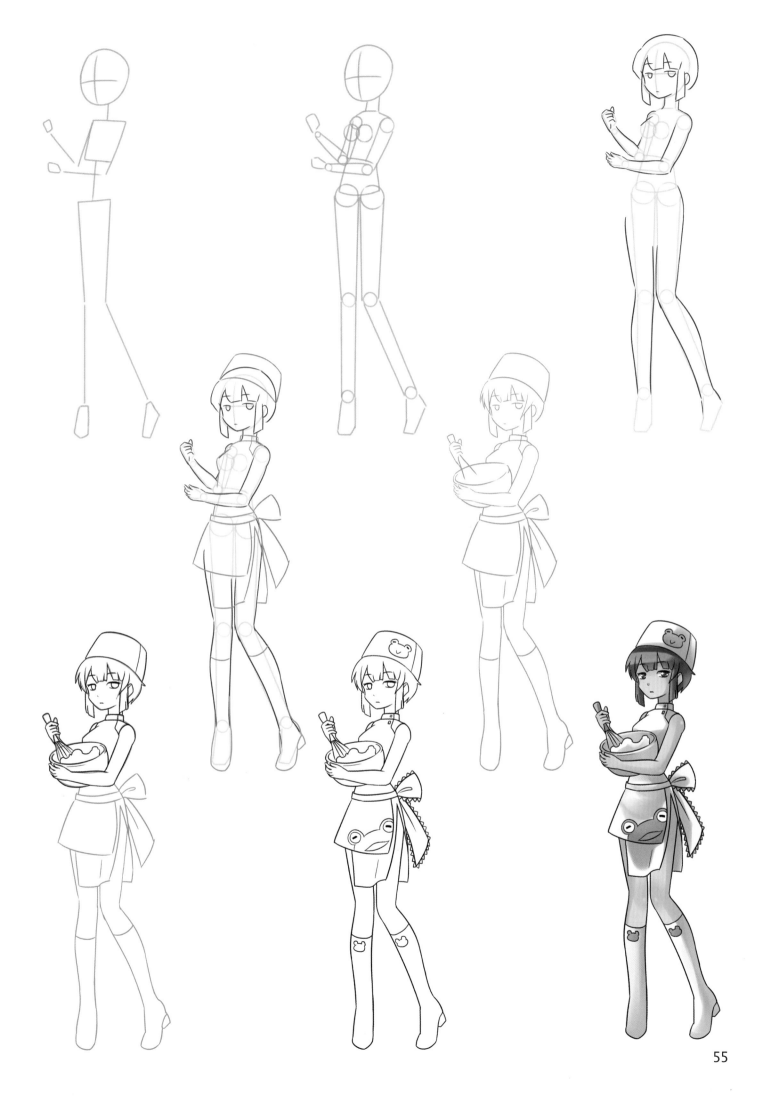

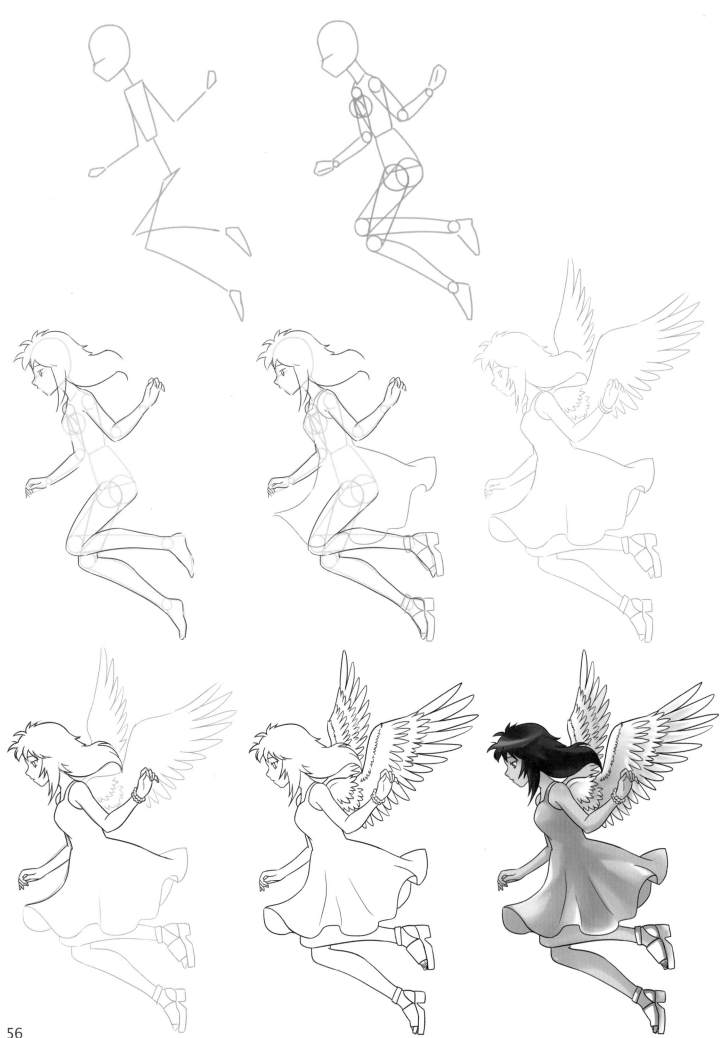

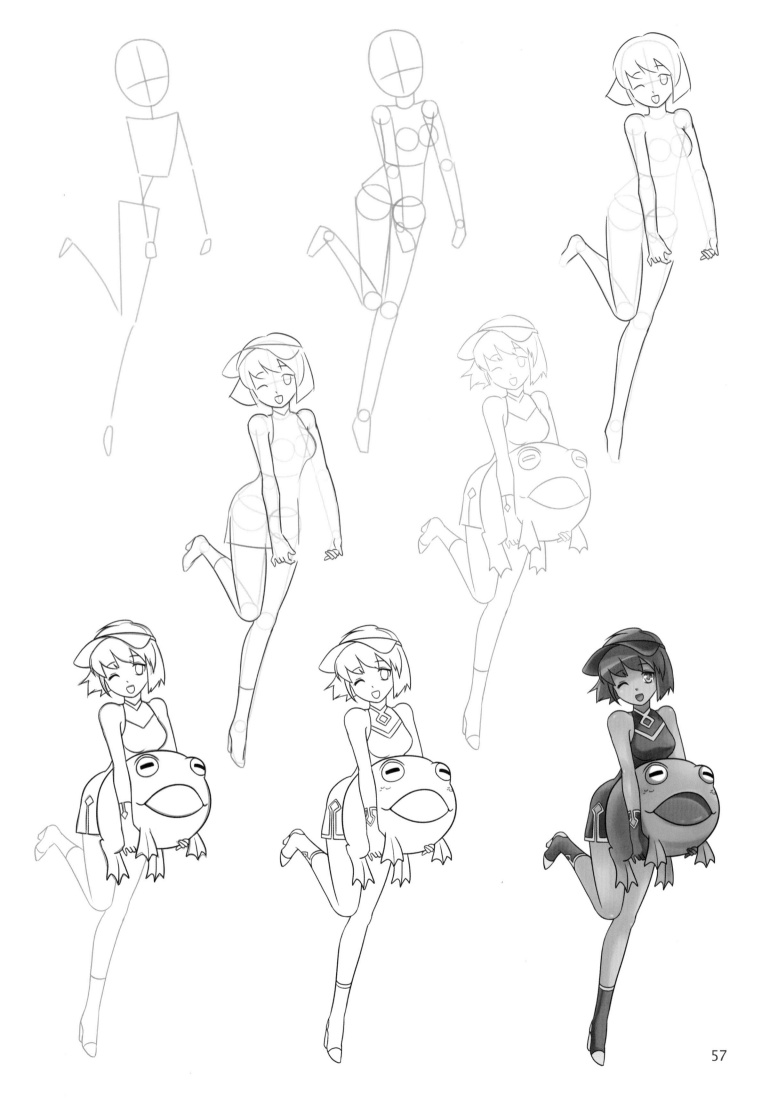

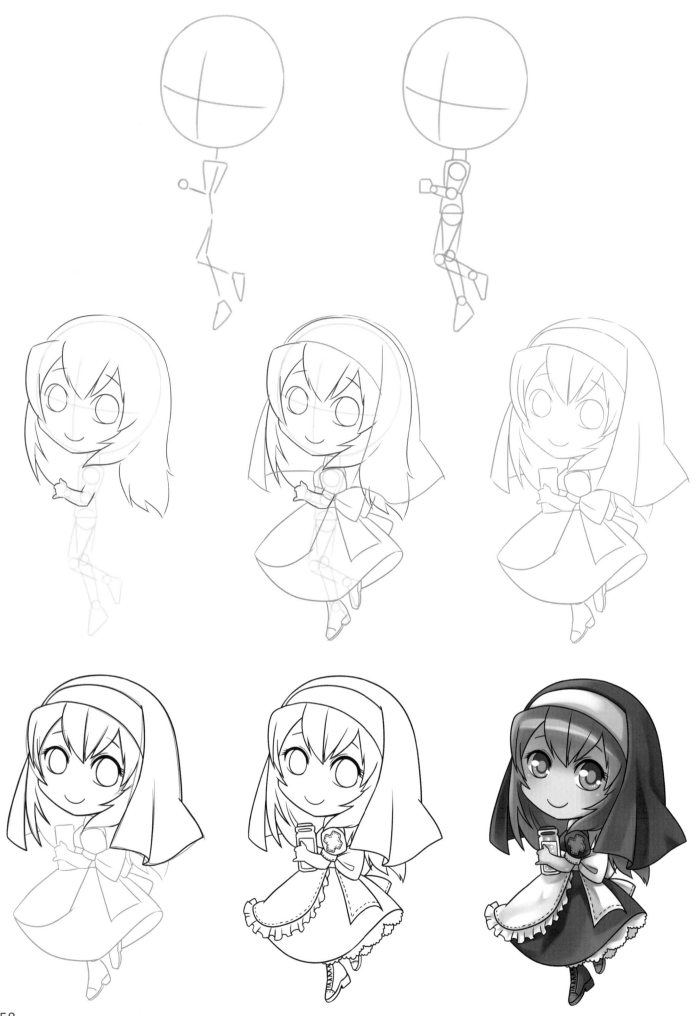

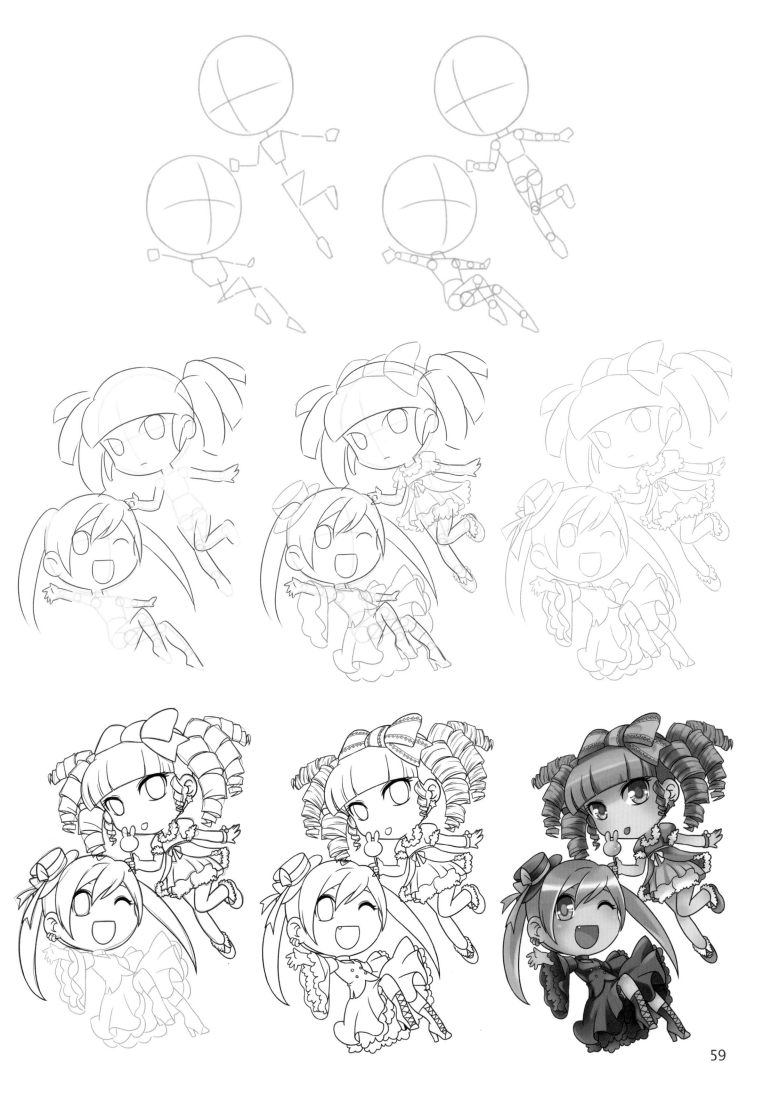

59

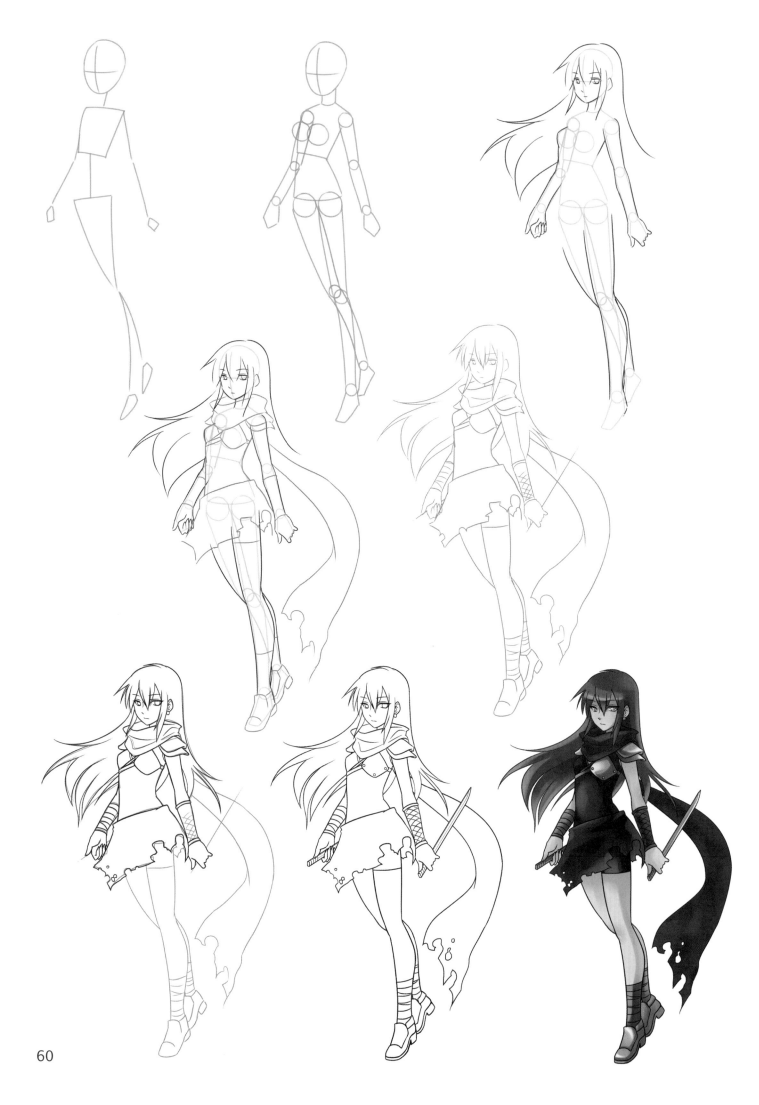

60

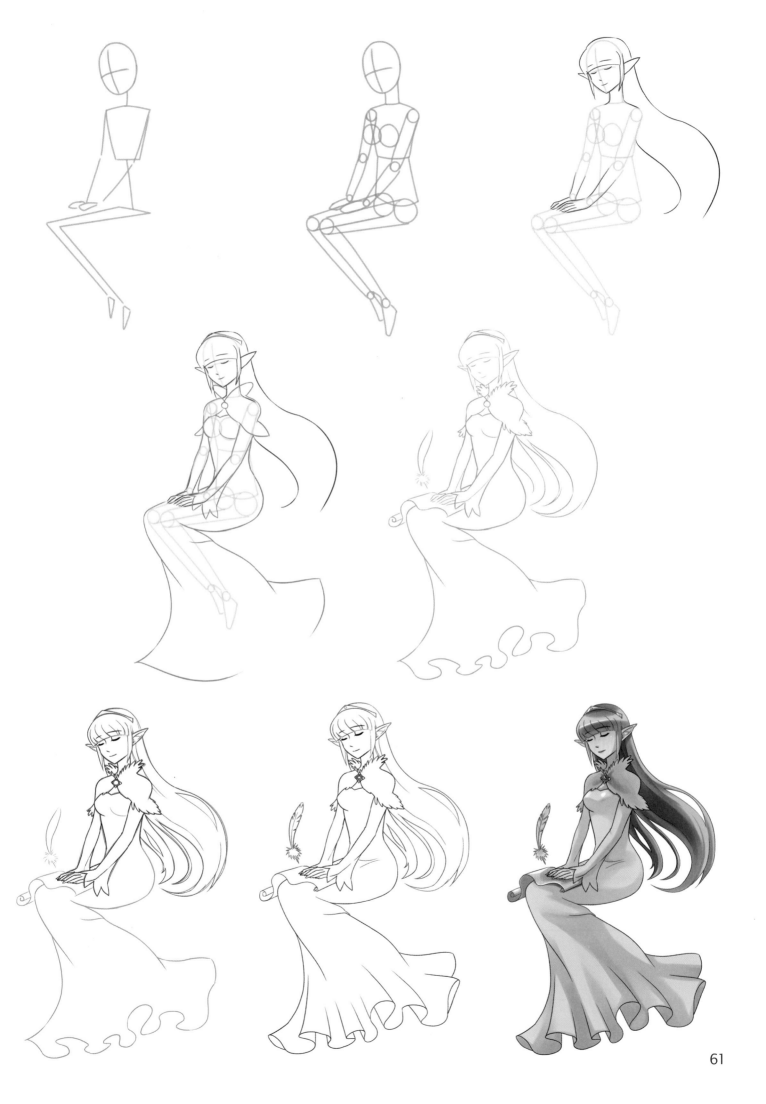

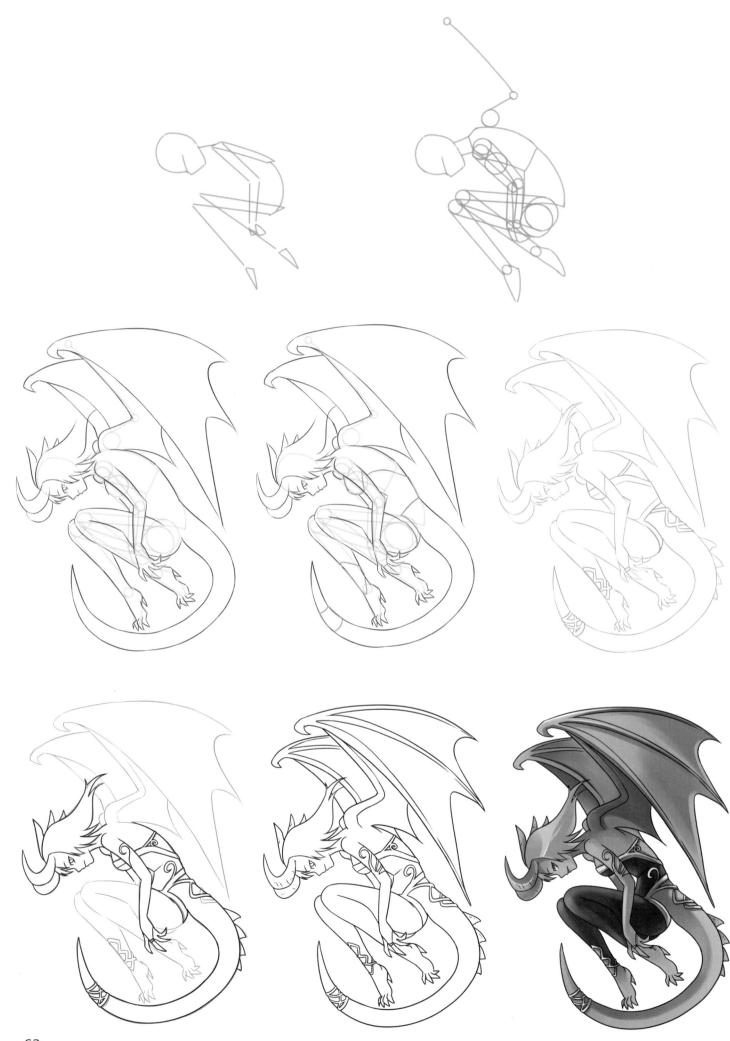

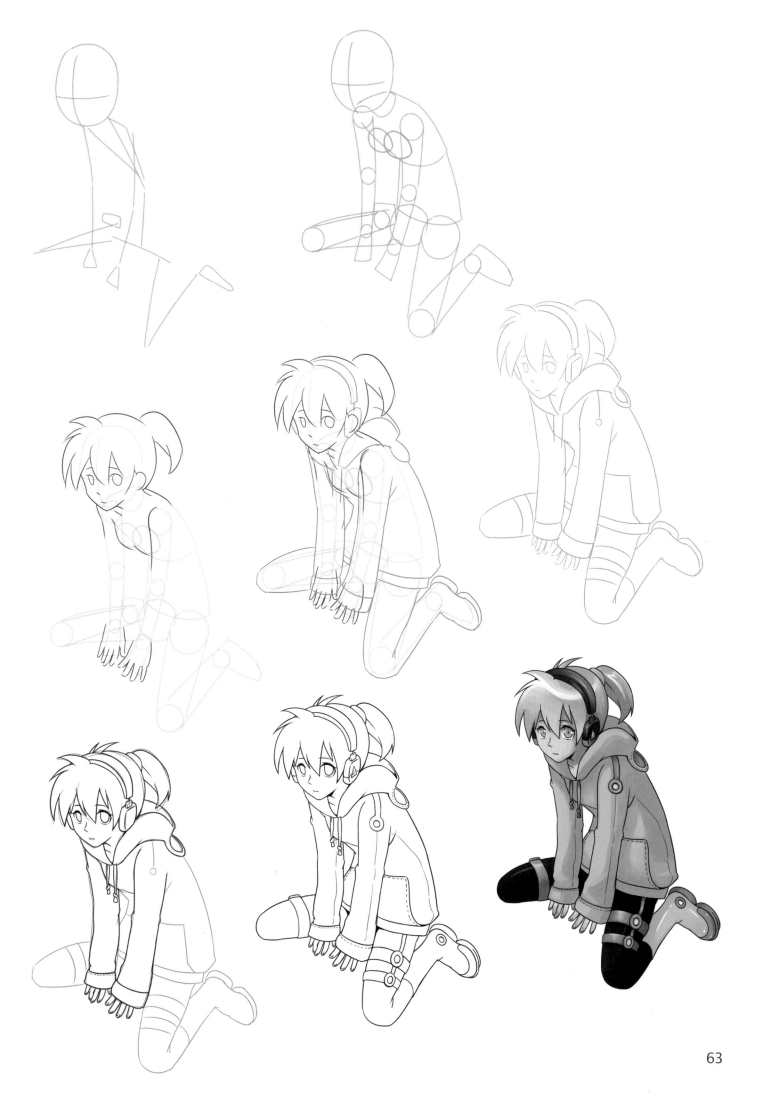

# MANGA ANIMALS

Animals appear very often in manga, sometimes as sidekicks, pets, or even evil predators. As with drawing manga humans, you can draw animals in a more realistic or exaggerated way; here I have focused on the realistic style as it is more complicated, and will provide a good basis to build on for the future. Animals can be harder to draw than humans, but with these simple step-by-steps you will be sketching your creatures in no time!

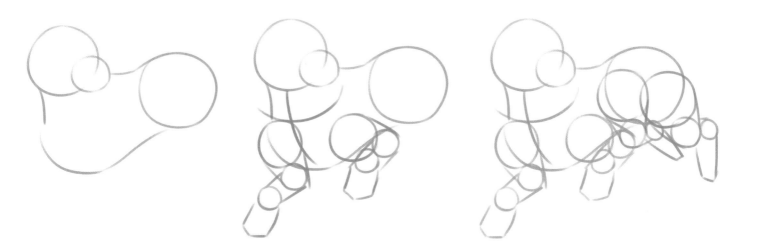

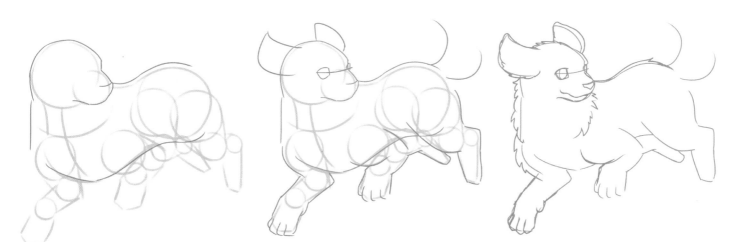

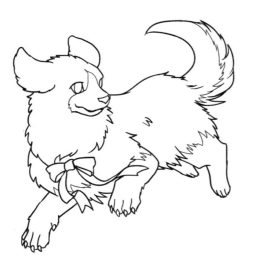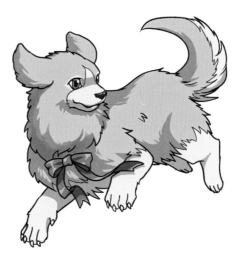

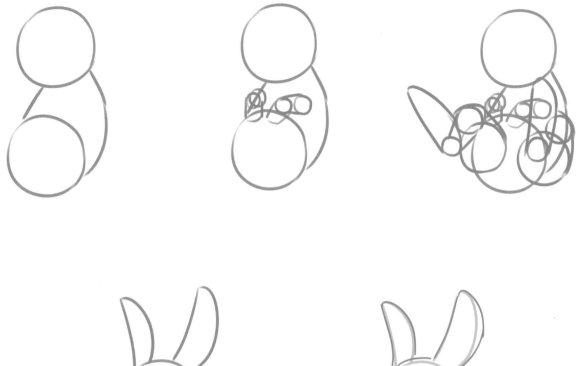

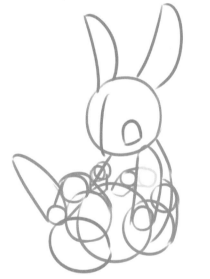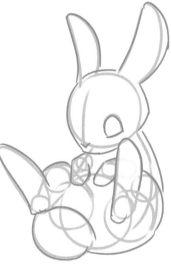

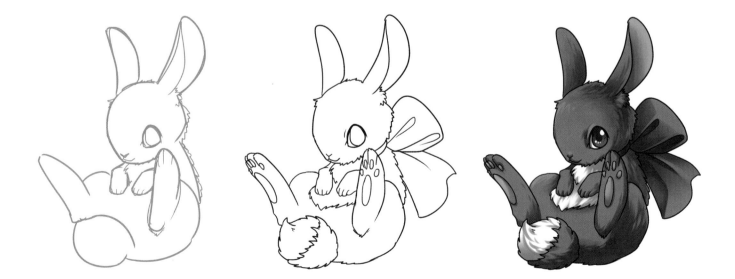

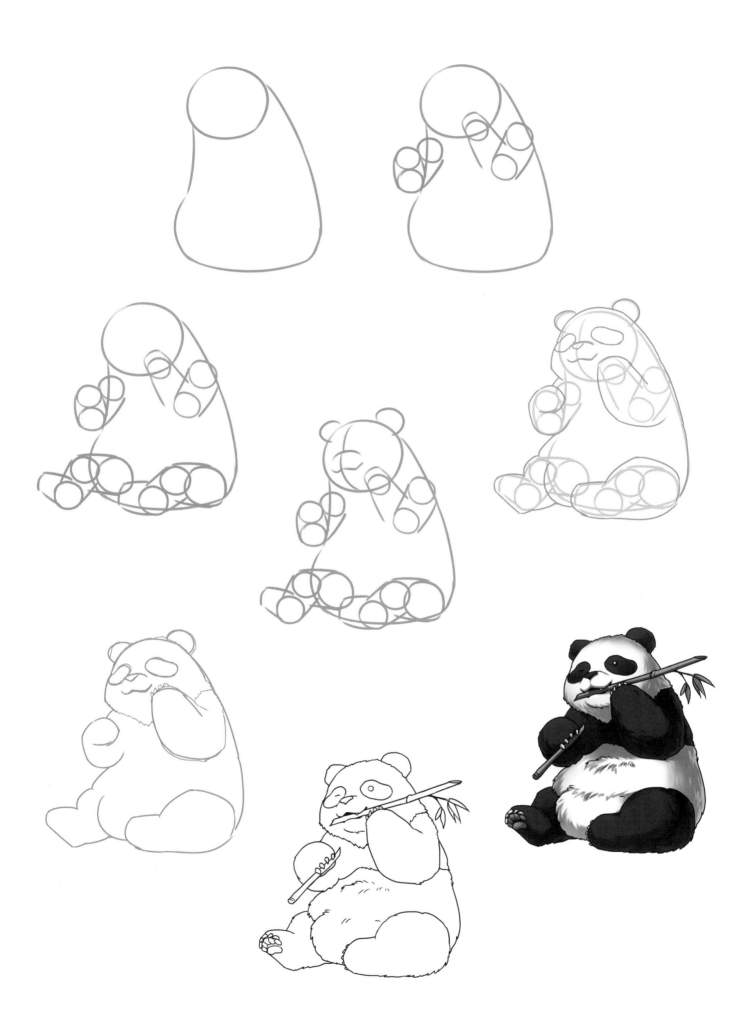

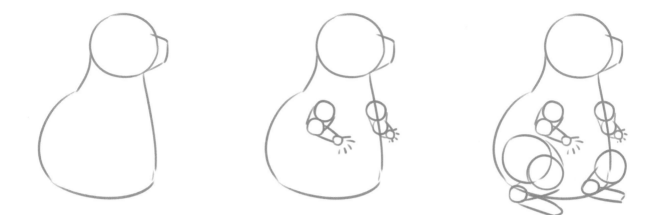

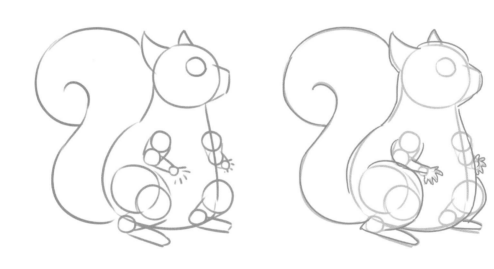

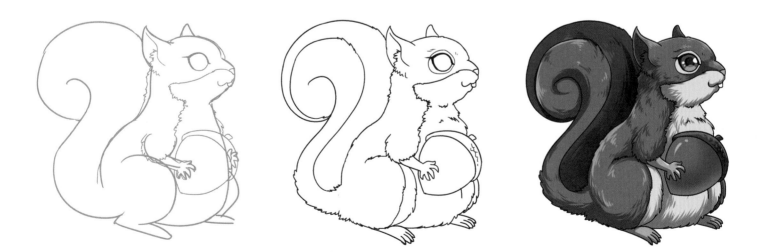

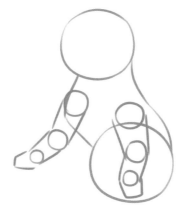

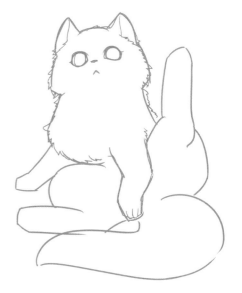
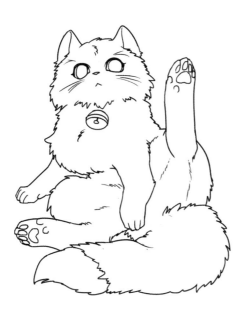
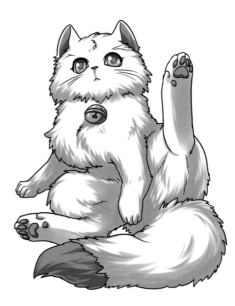

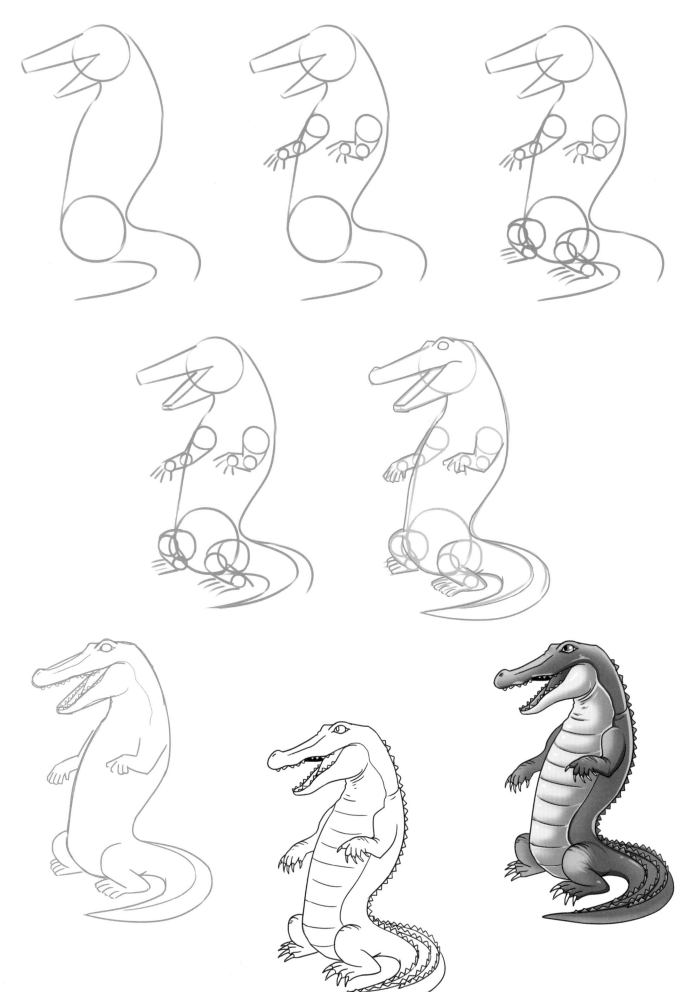

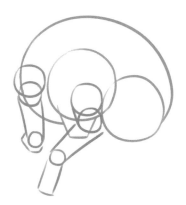
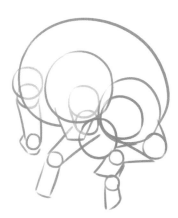
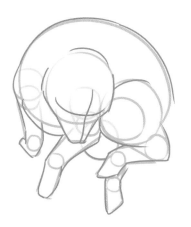
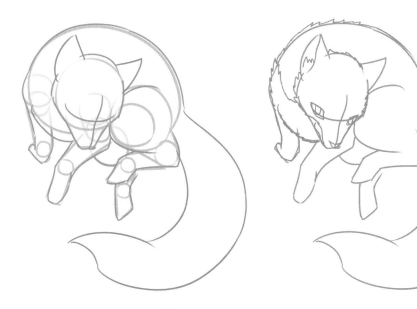
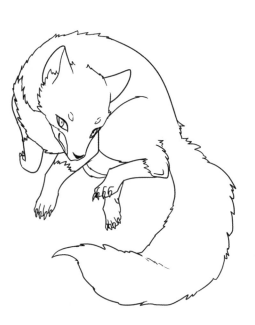
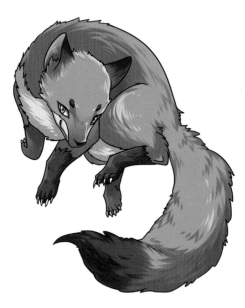

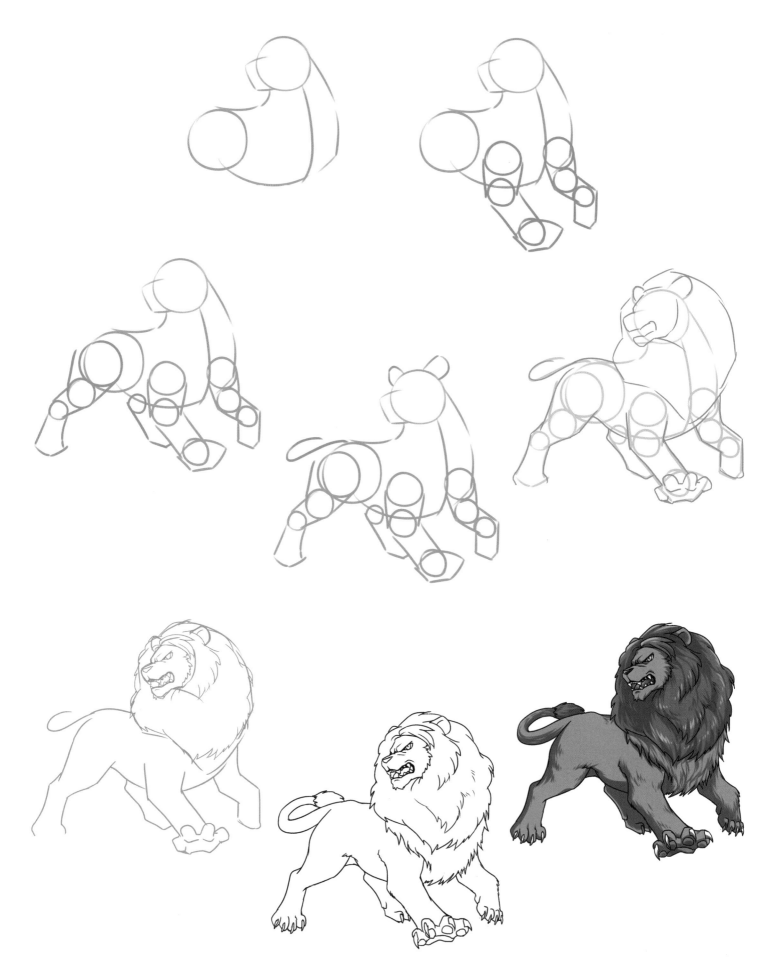

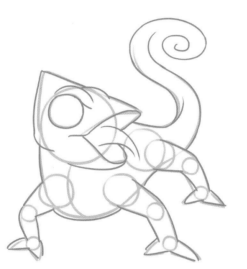
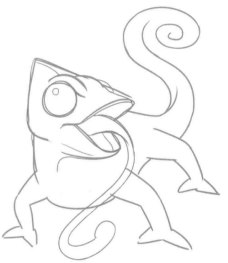
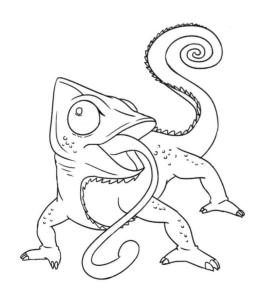
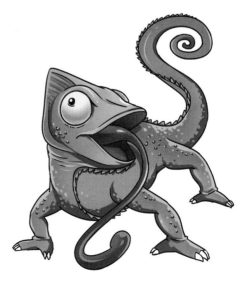

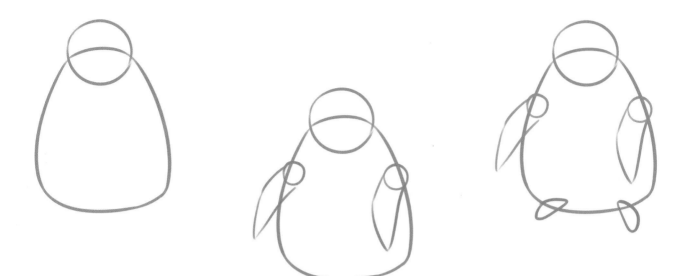

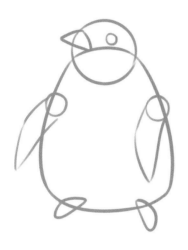
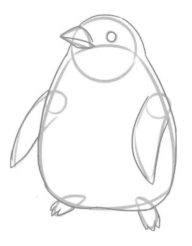

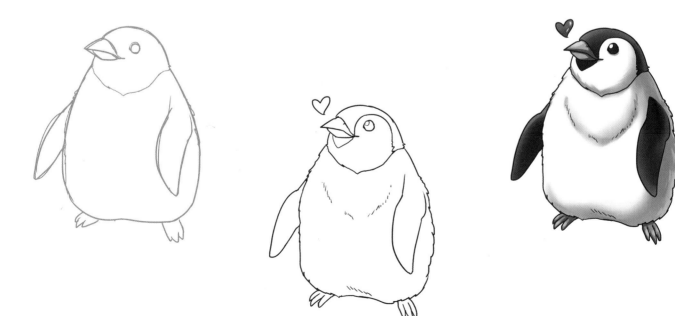

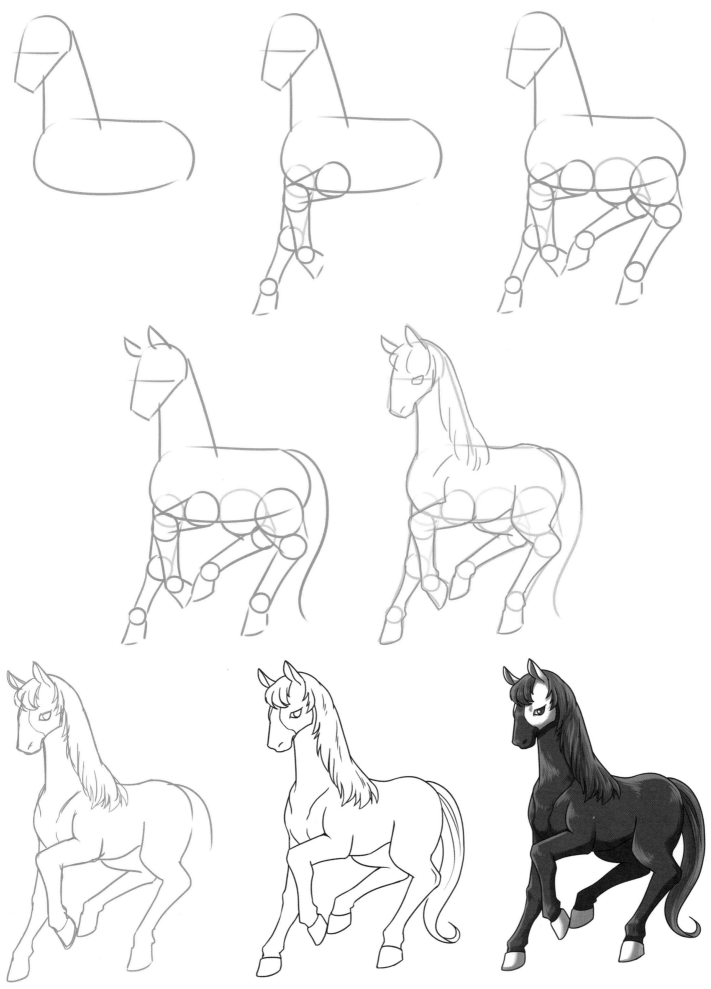

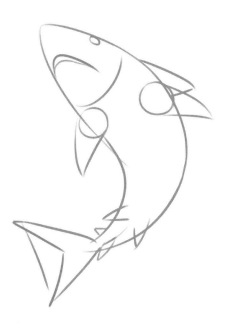
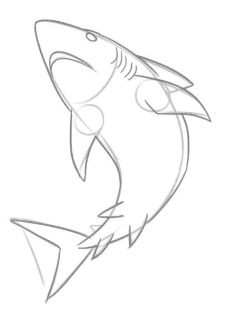
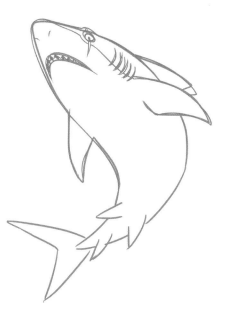
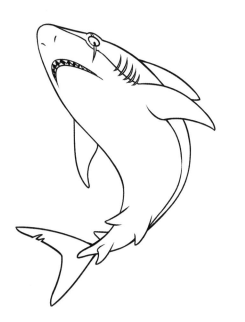
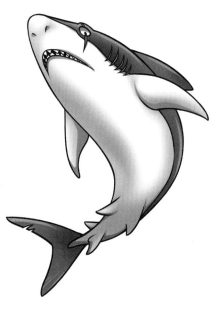

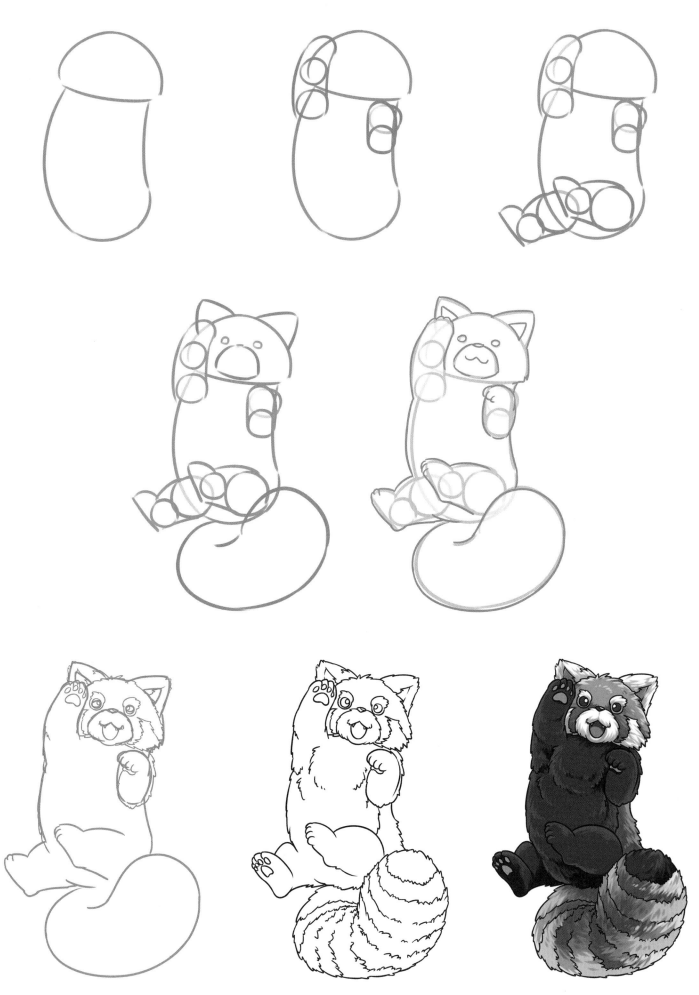

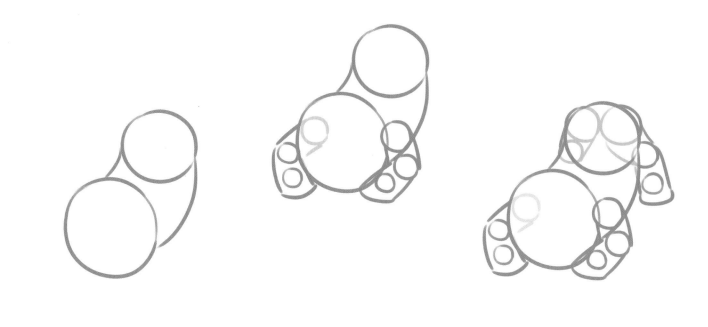

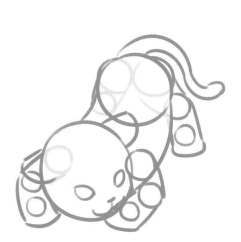

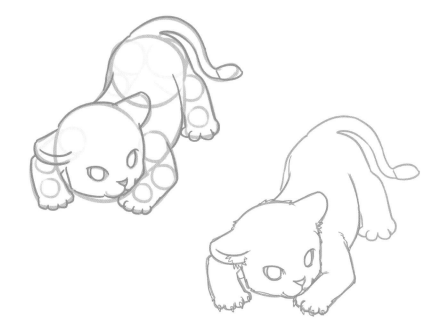

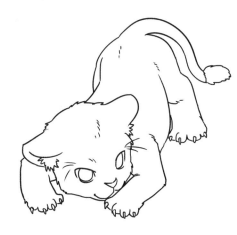

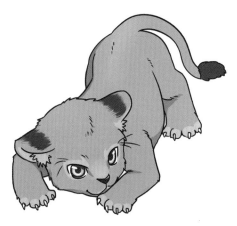

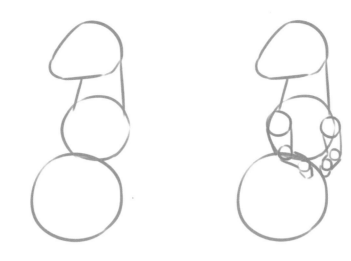

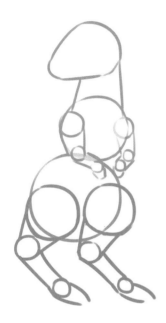

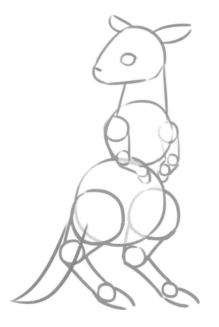

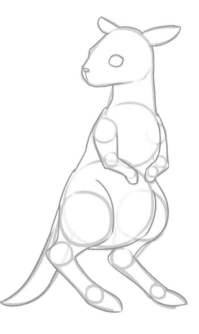

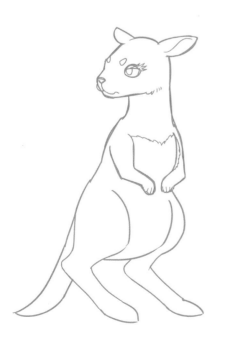

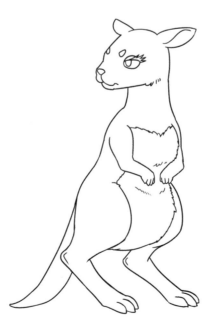

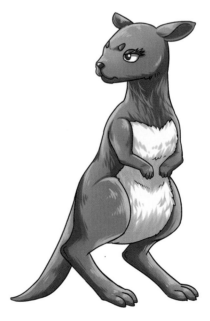

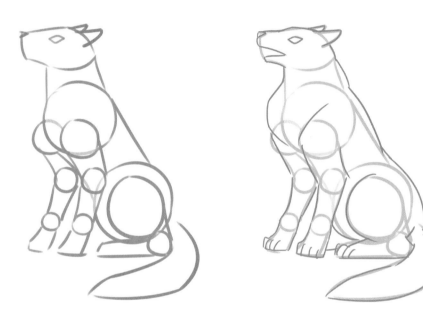
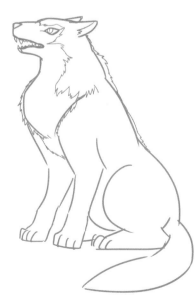
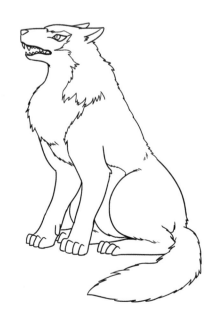
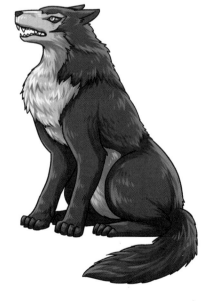

80

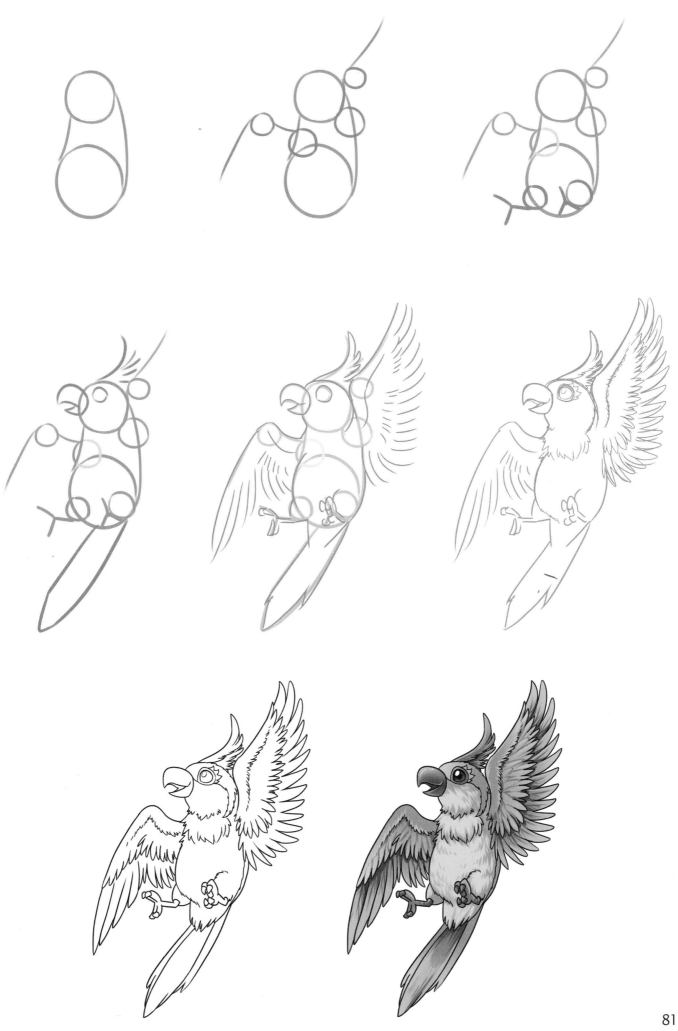

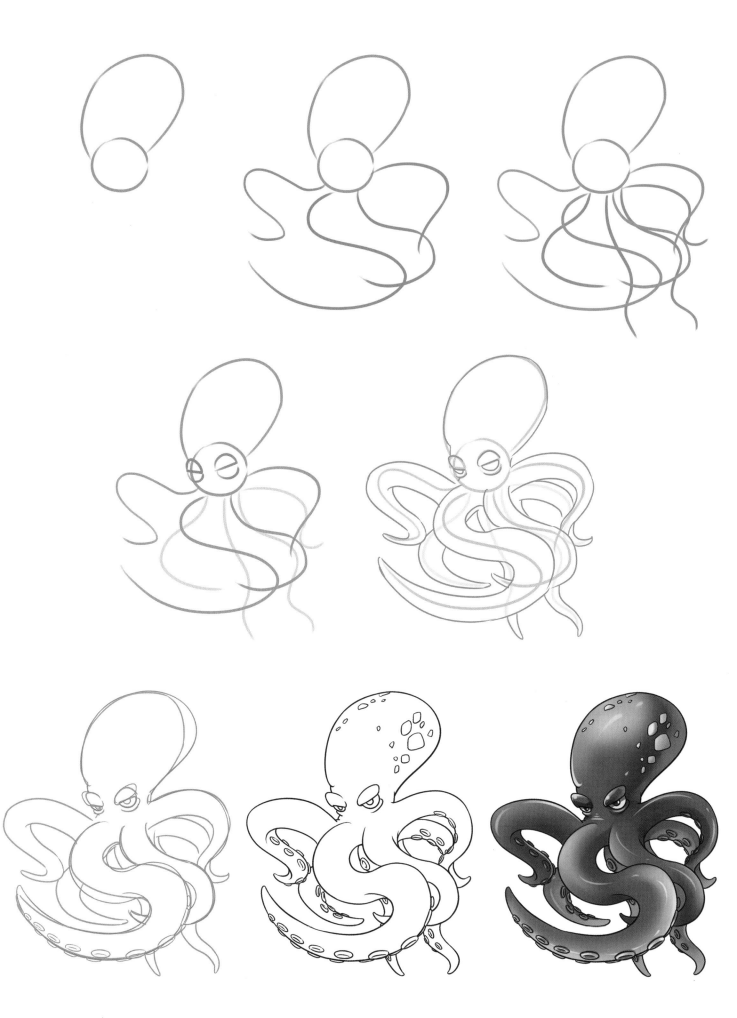

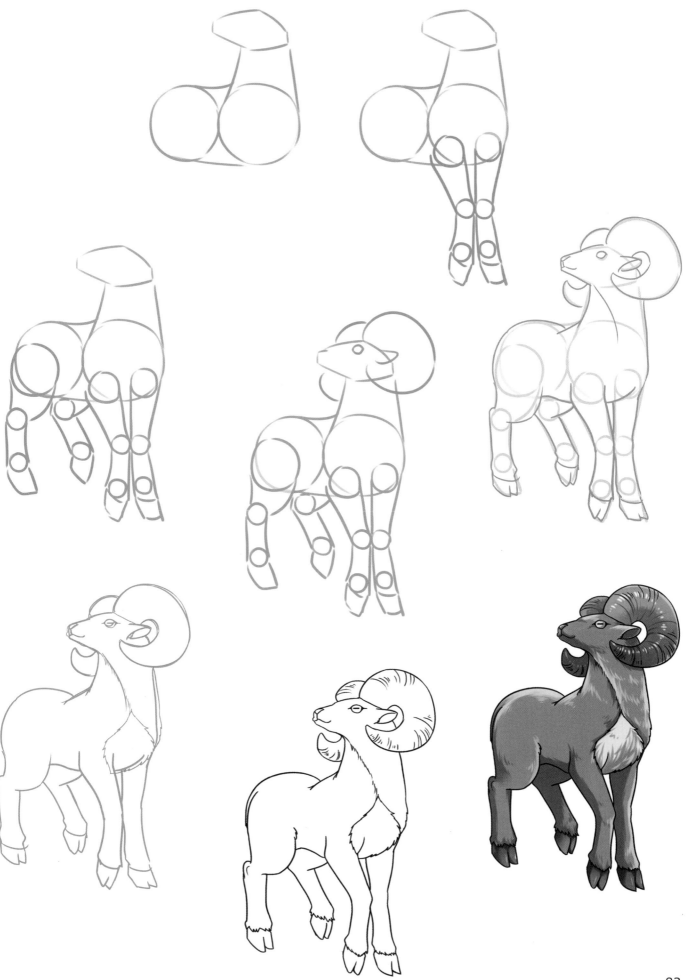

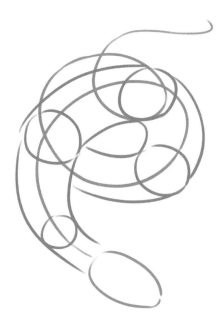
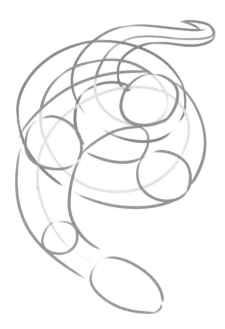
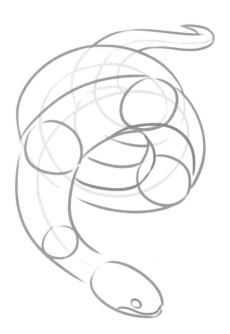
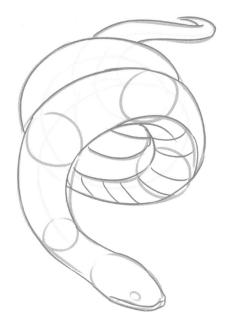
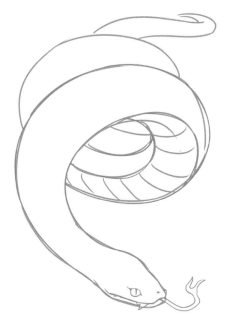
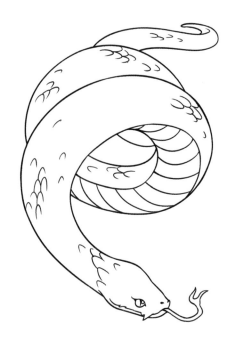
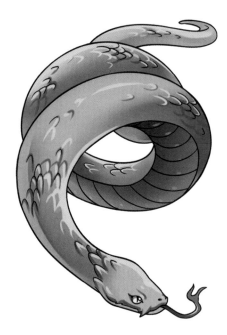

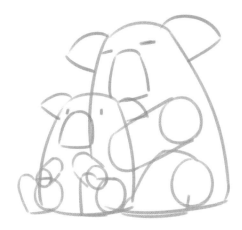

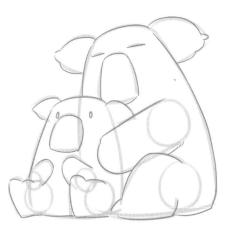

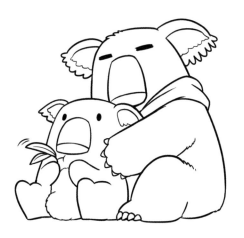

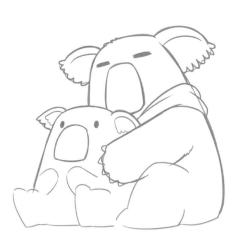

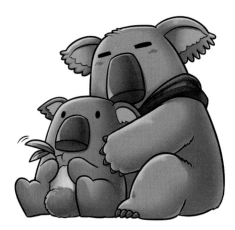

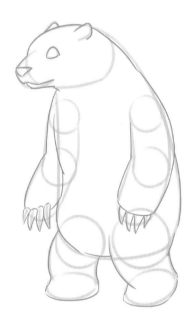

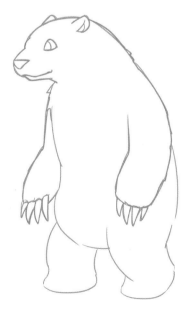
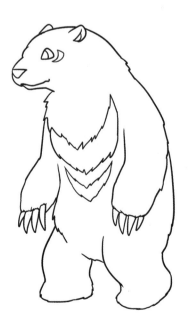
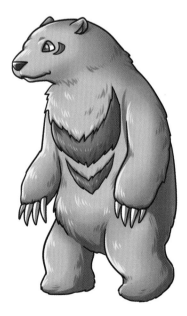

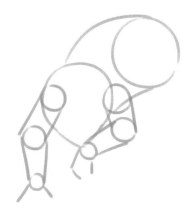
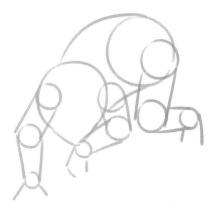
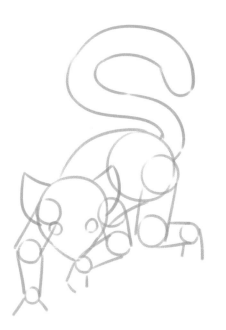
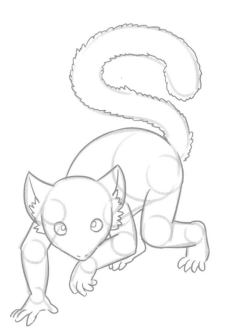
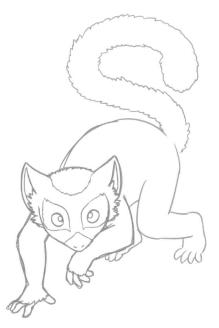
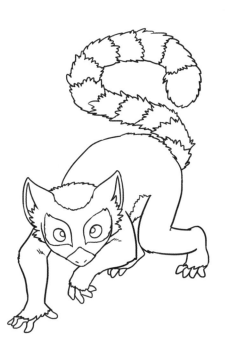
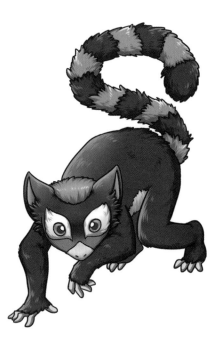

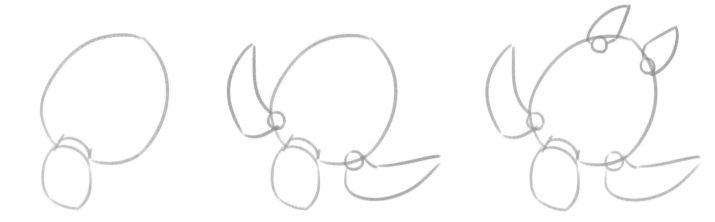

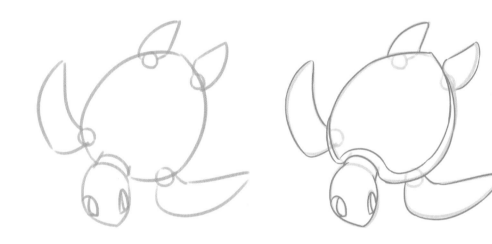

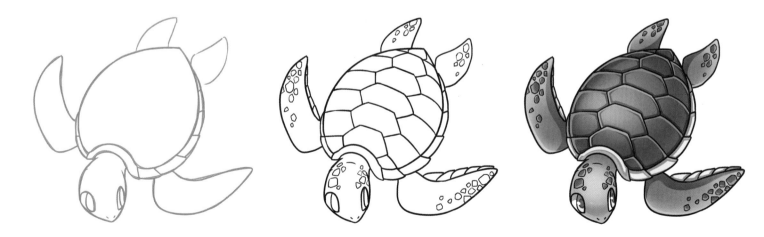

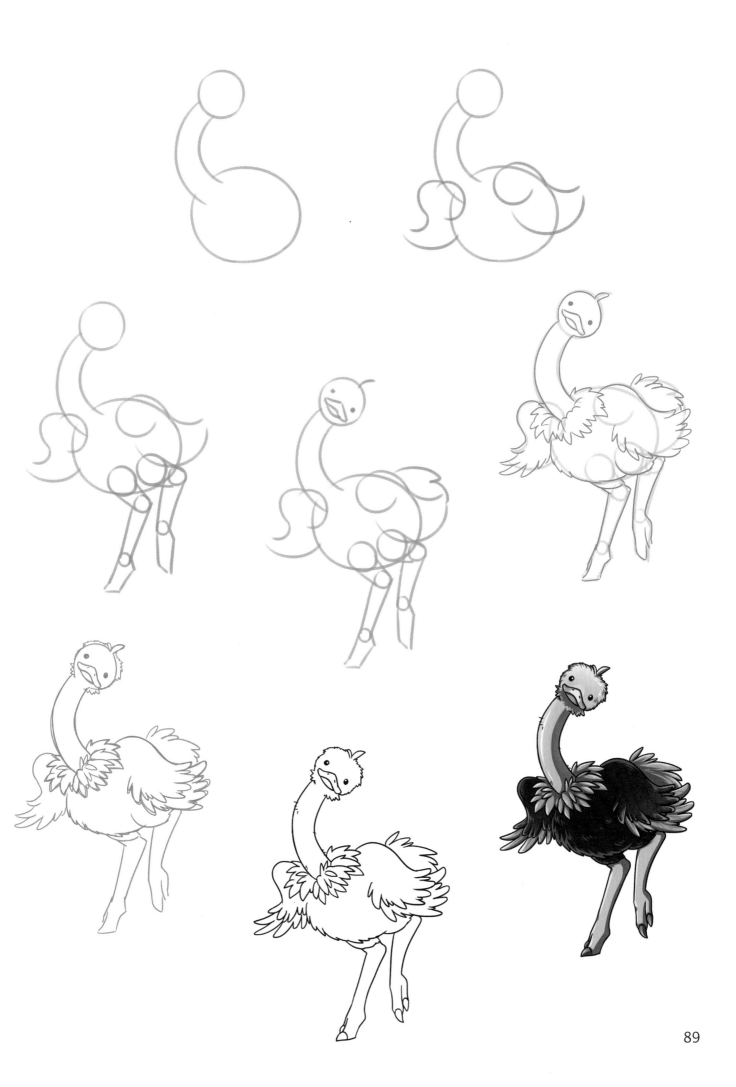

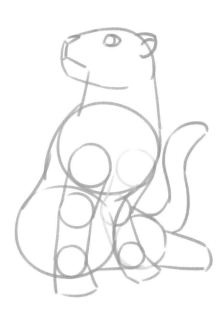
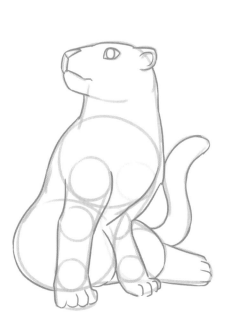
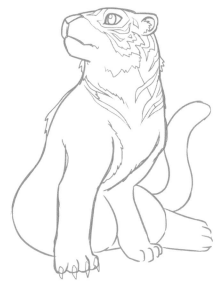
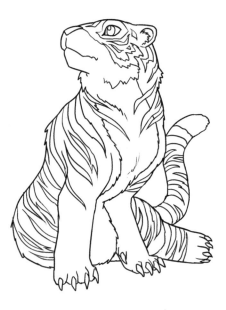
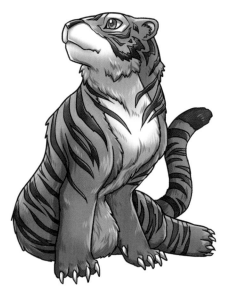

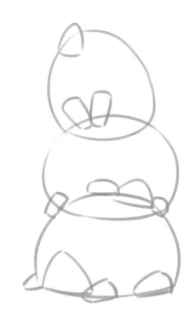
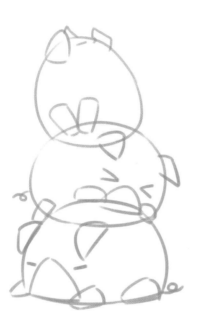
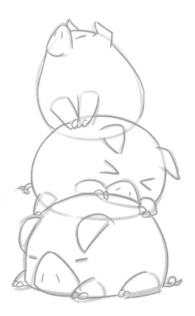
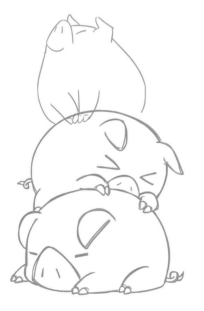
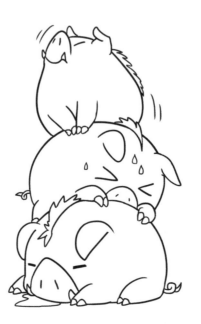
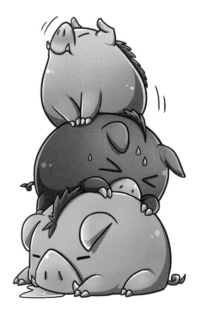

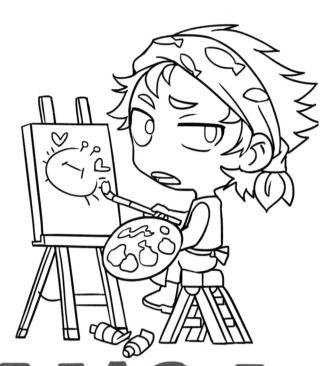

# MANGA CHIBIS

Chibi is a Japanese word meaning 'small person' and is a simple, cute style of drawing in manga. Normally chibis are 'super-deformed' to the most adorable way possible – huge eyes, tiny nose (or no nose), child-like bodies and very expressive emotions. The chibi style is usually used in scenes which are funny and/or cute.

Chibis are relatively easy to draw compared with normal-sized characters, because the body structure is much simpler and the faces more stylised. For this reason they are a good starting point when learning to draw manga.

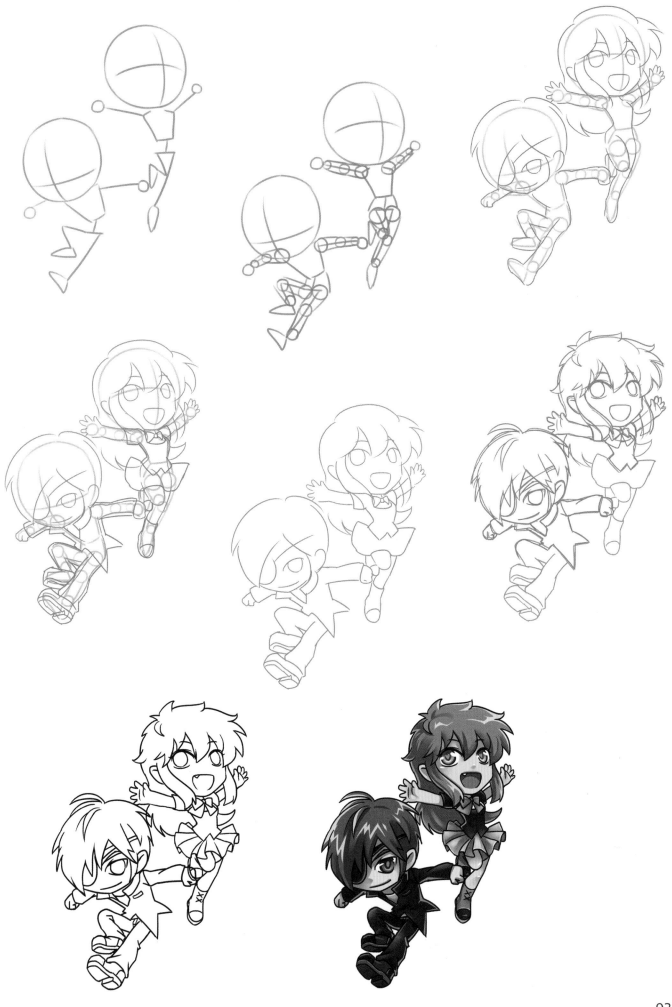

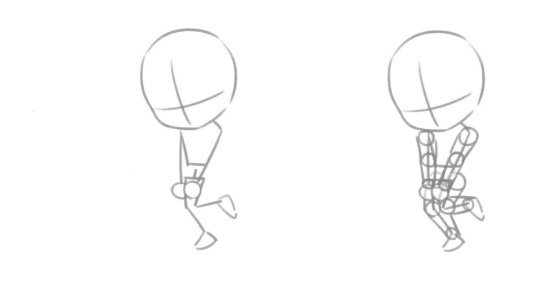

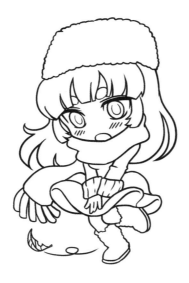

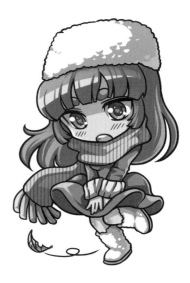

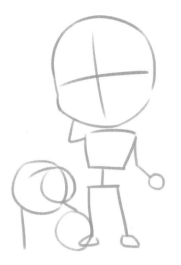
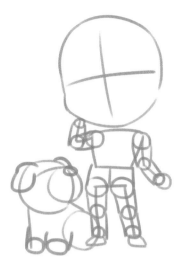
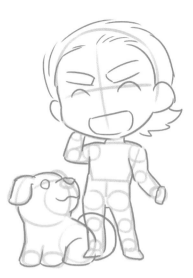
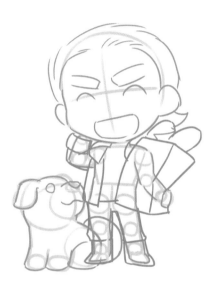
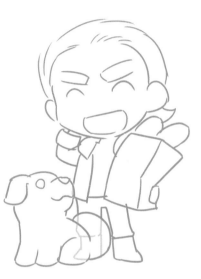
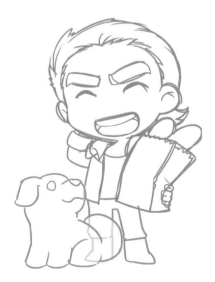
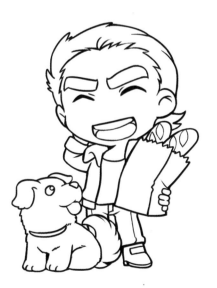
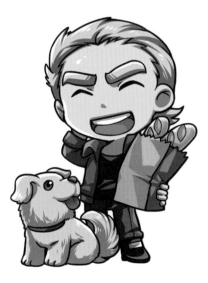

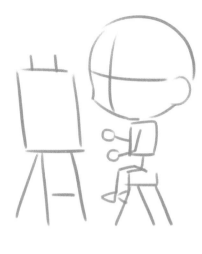
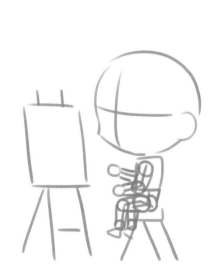
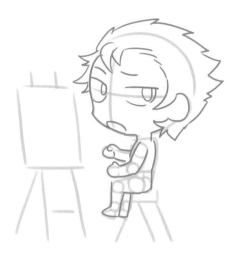
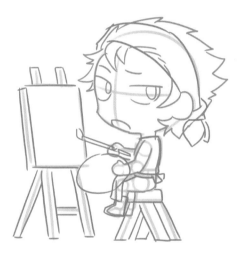
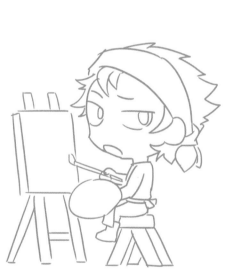
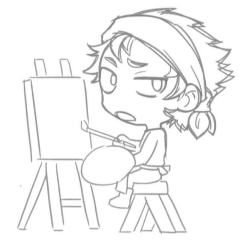
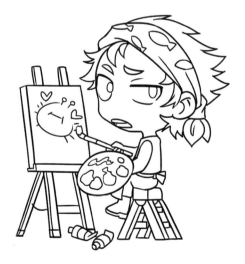
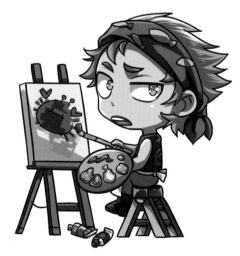

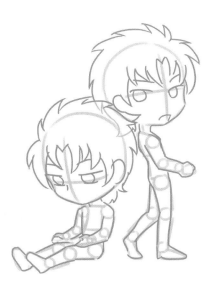
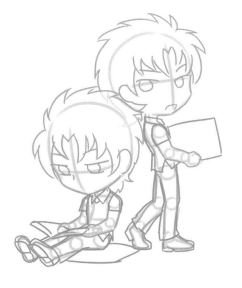
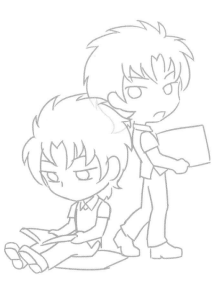
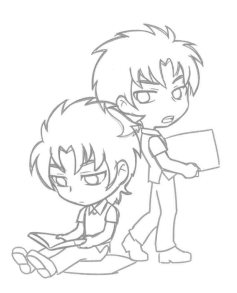
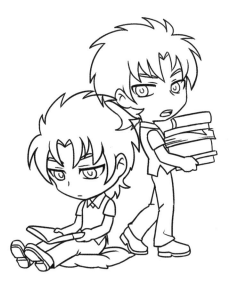
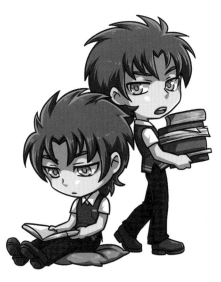

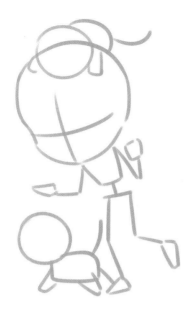
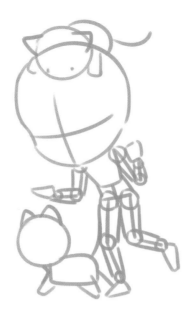
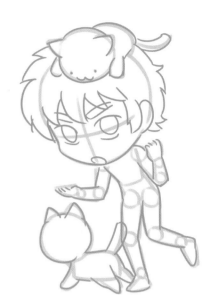
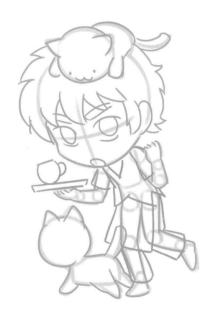
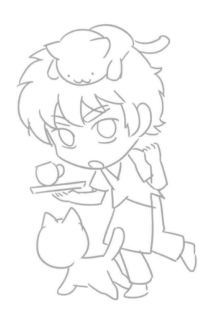
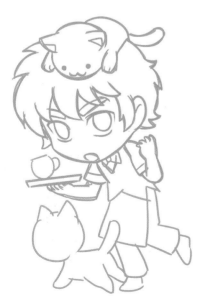
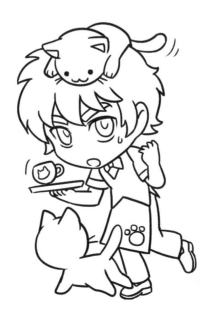
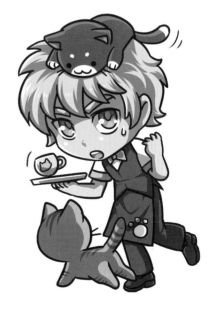

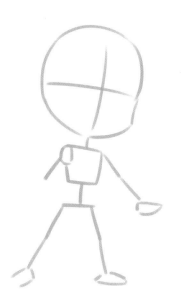
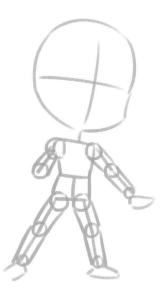
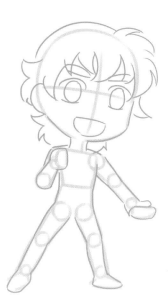
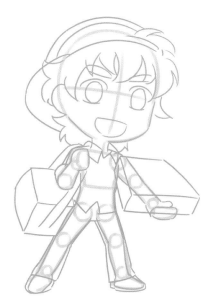
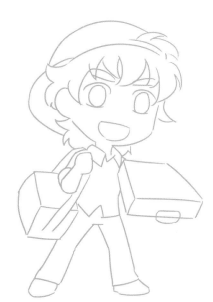
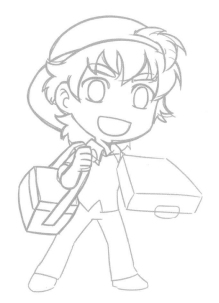
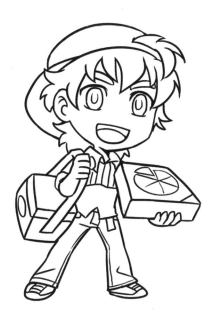
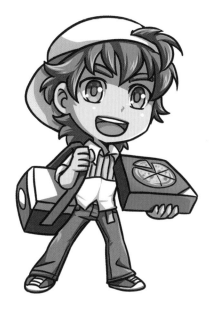

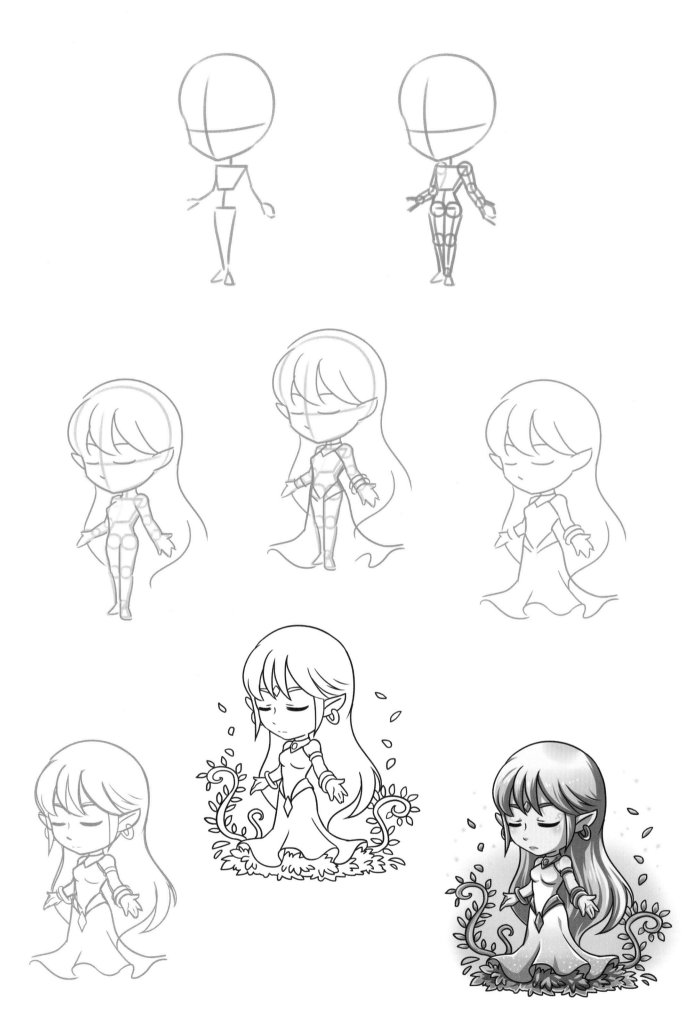

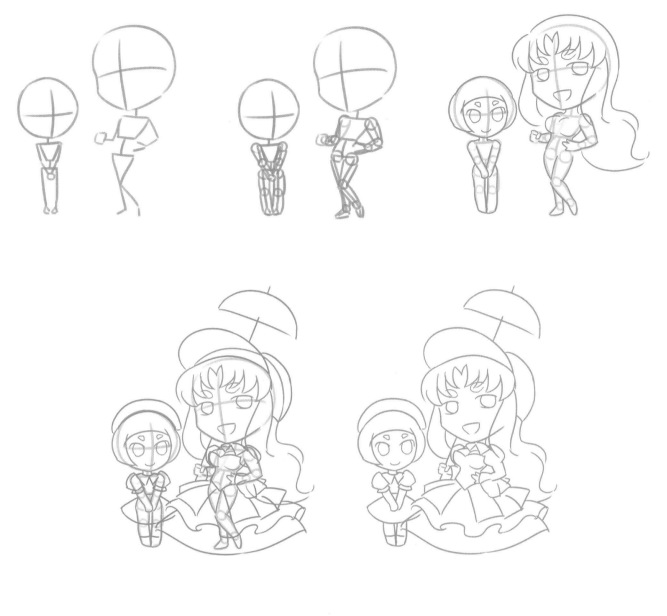

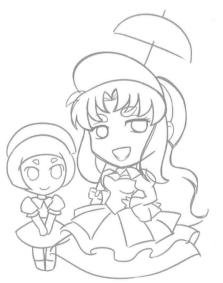

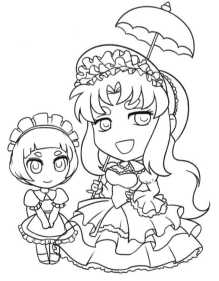

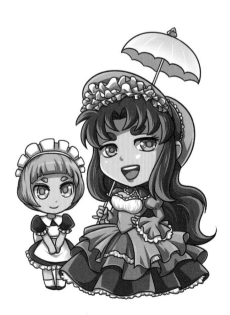

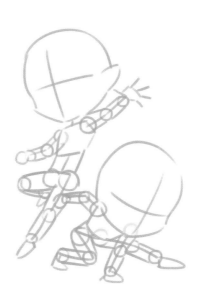
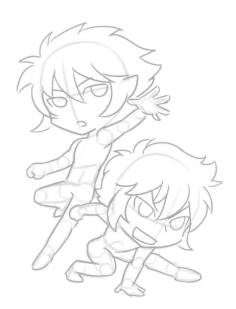
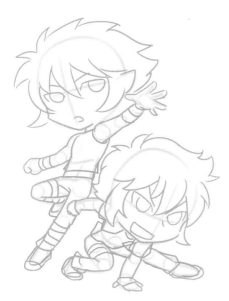
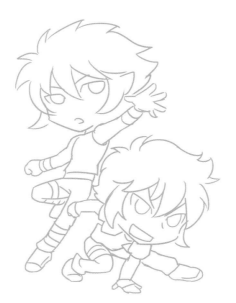
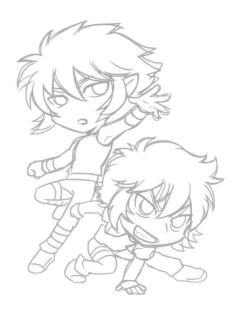
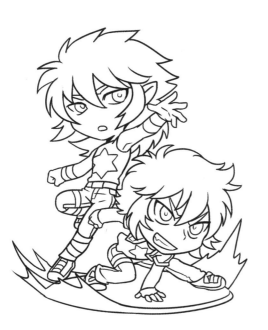
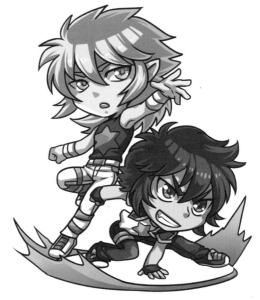

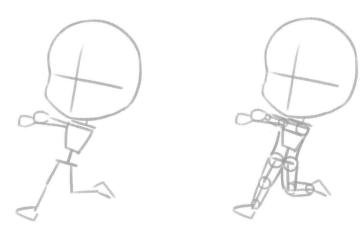

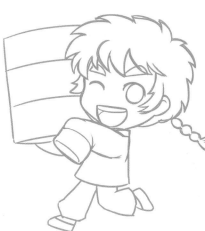

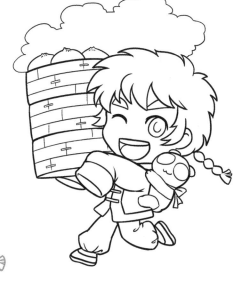

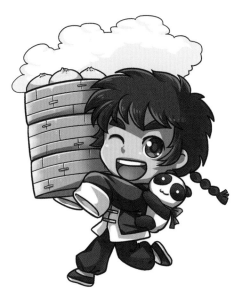

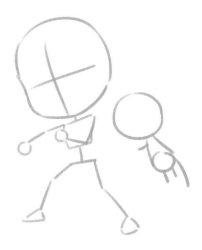

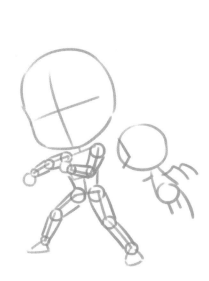

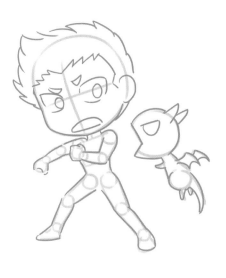

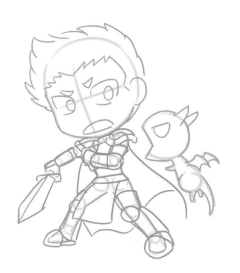

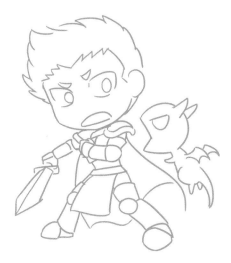

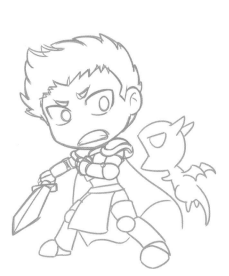

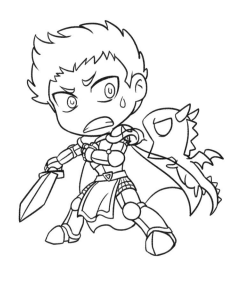

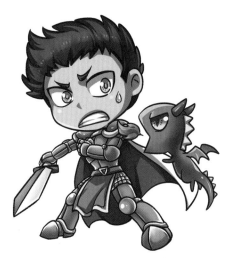

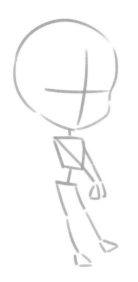
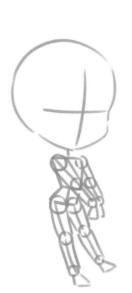

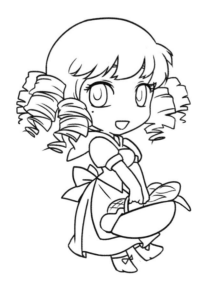
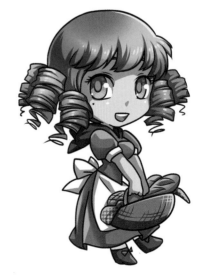

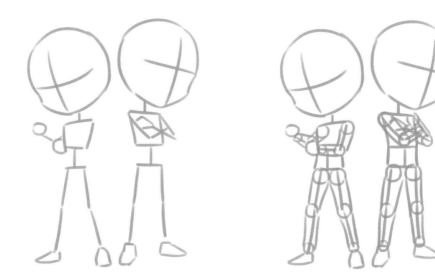

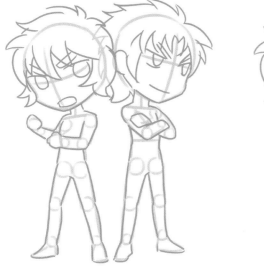

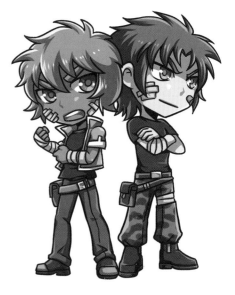

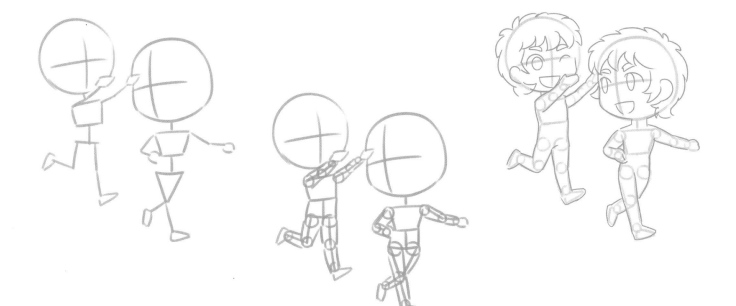

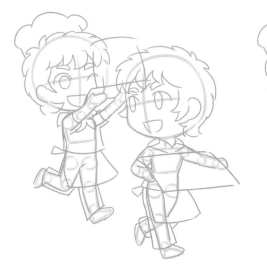

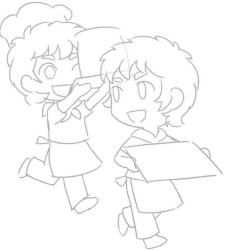

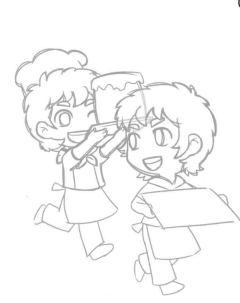

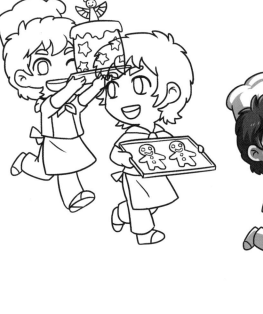

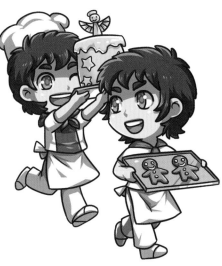

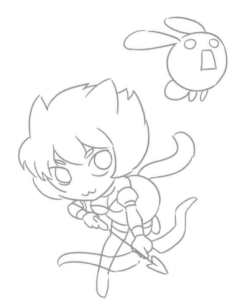
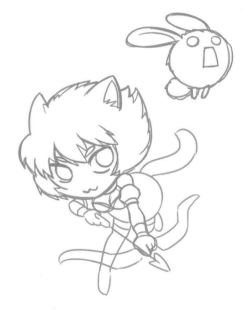
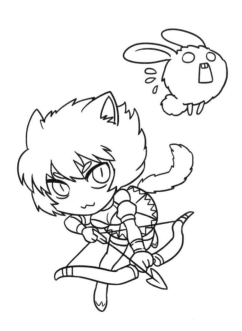
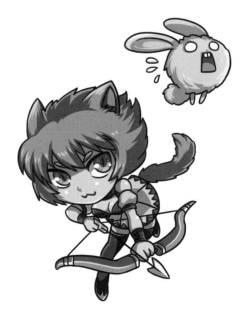

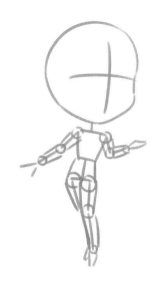
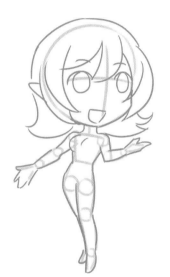
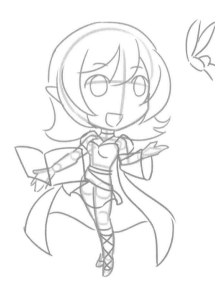
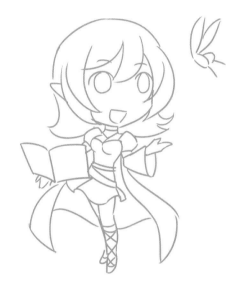
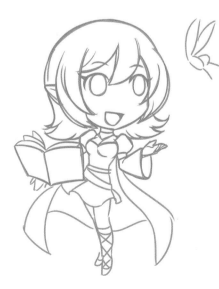
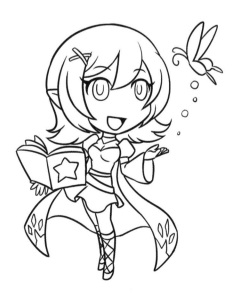
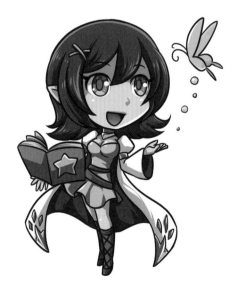

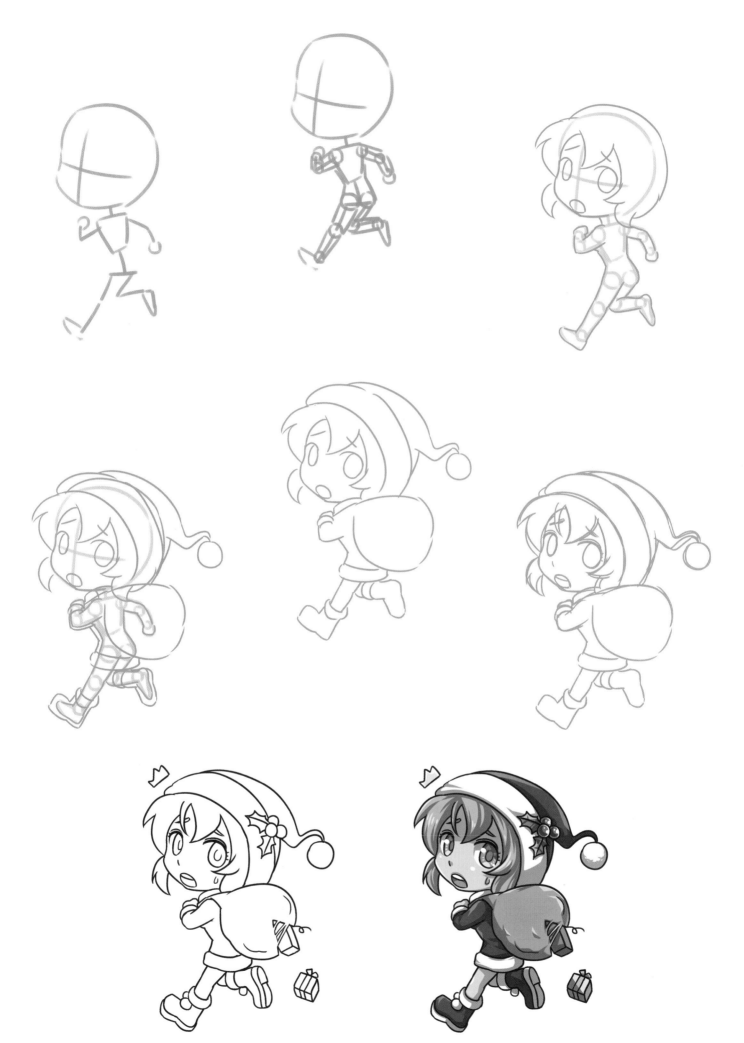

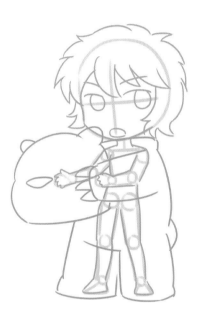
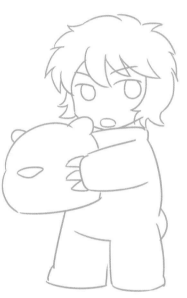
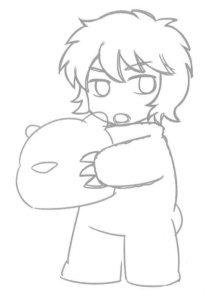
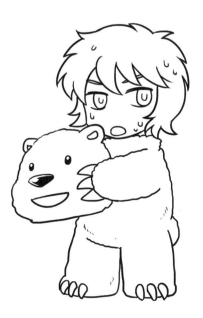
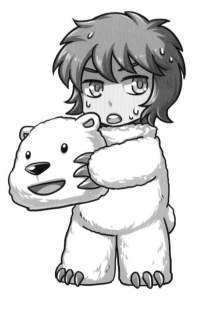

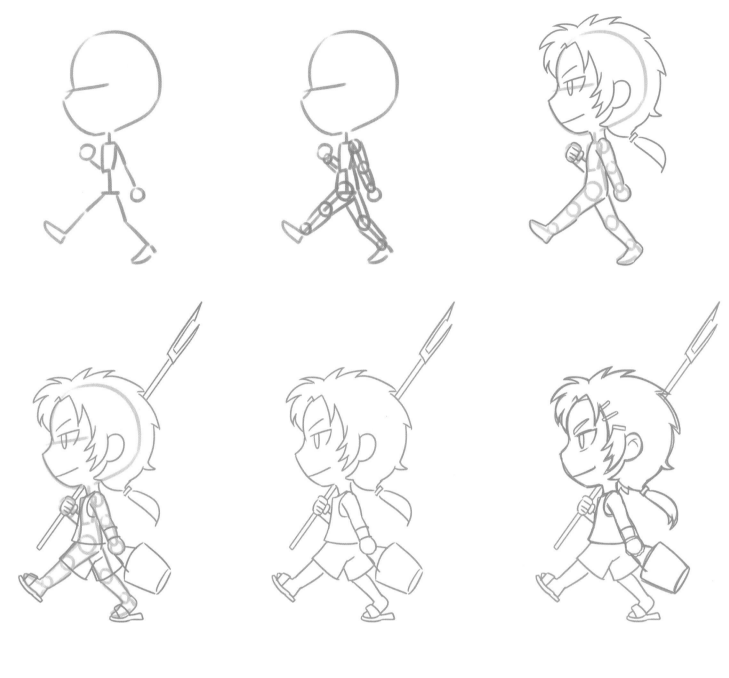

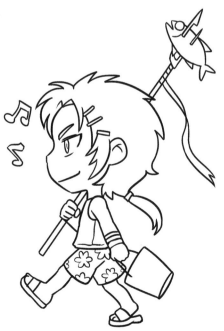

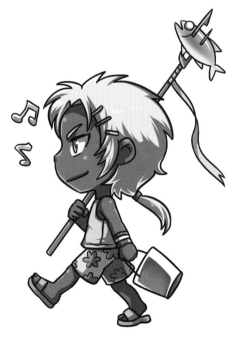

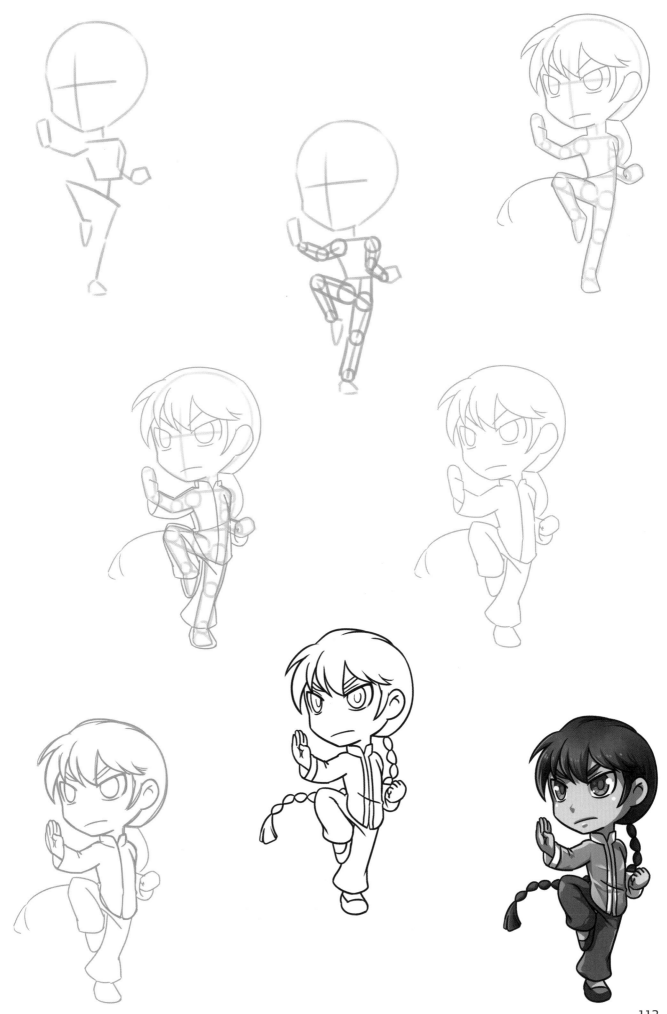

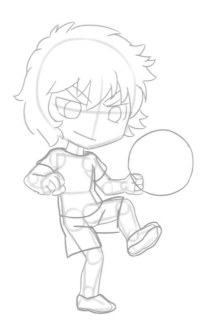
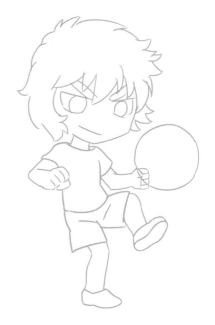
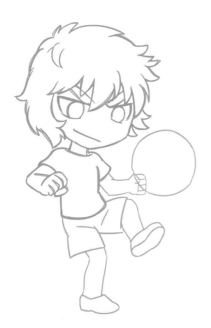
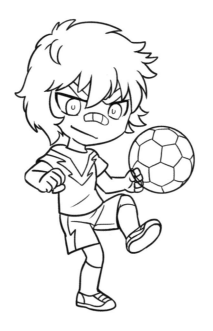
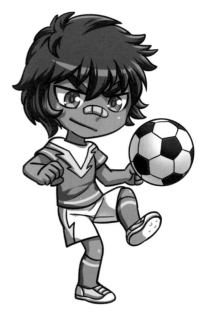

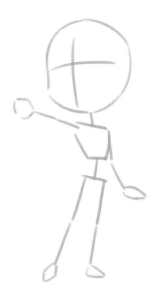
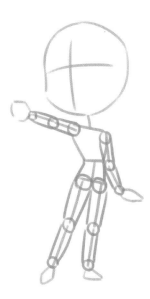
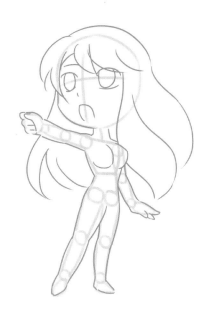
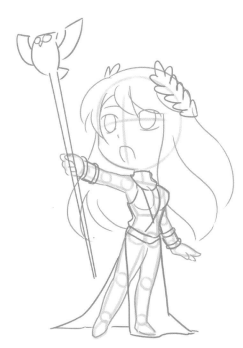
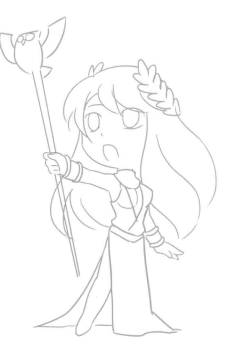
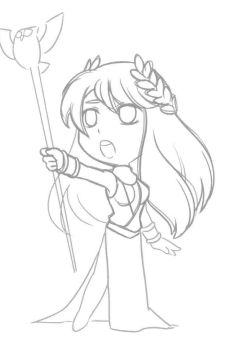
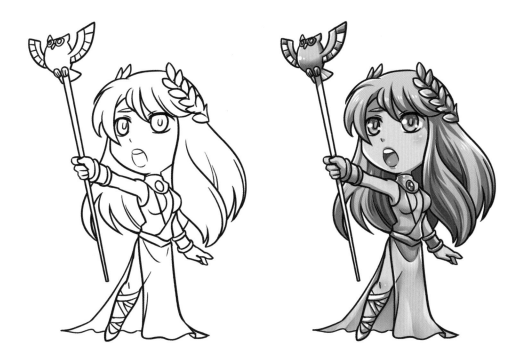

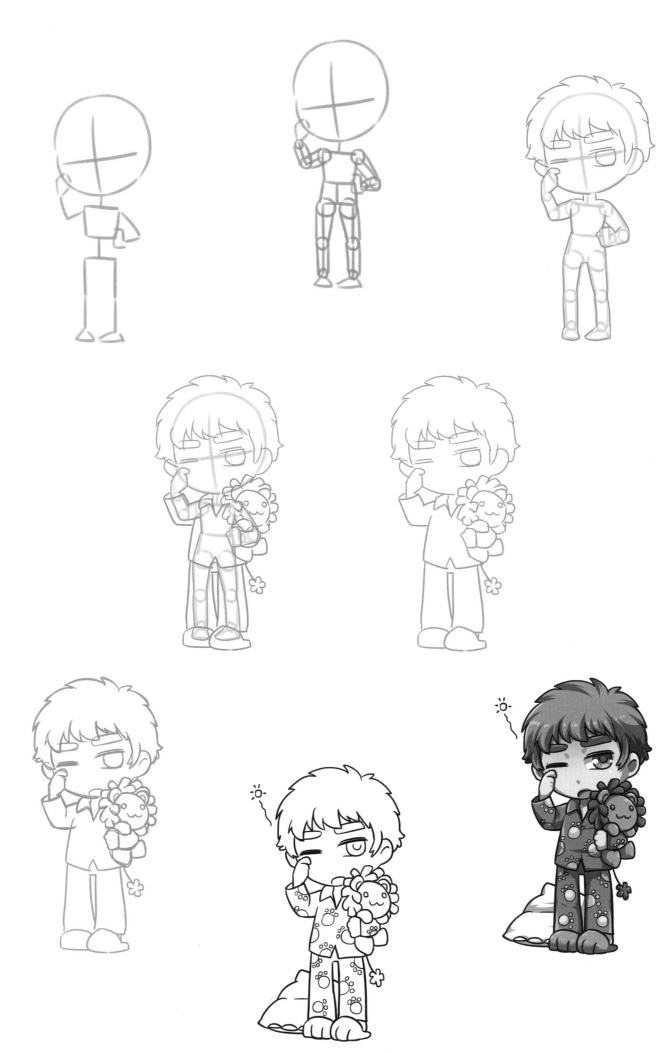

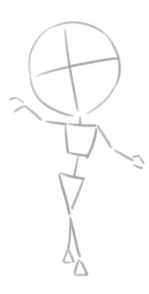
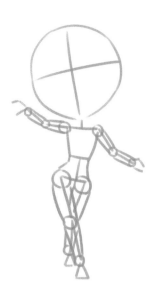
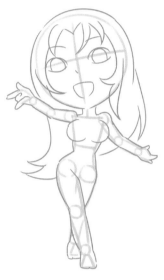
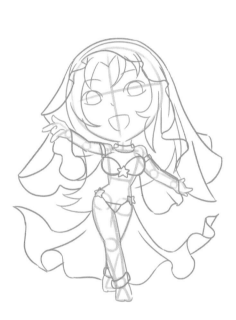
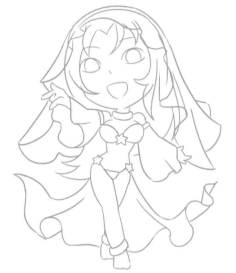
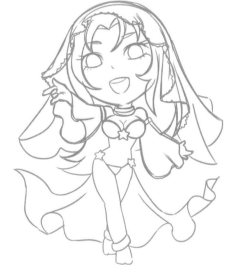
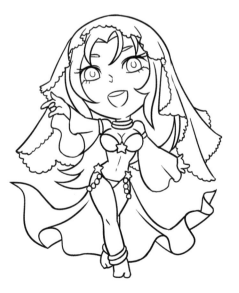
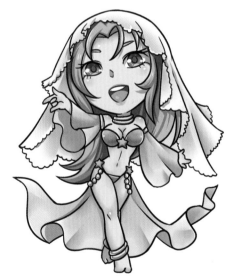

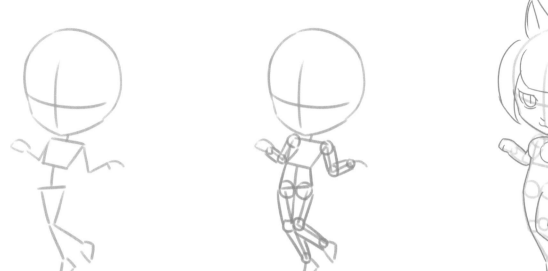
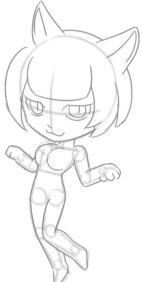
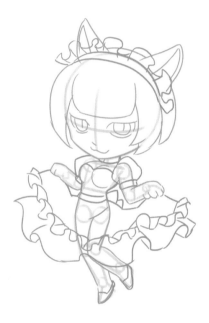
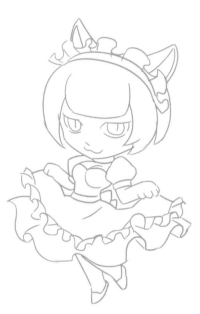
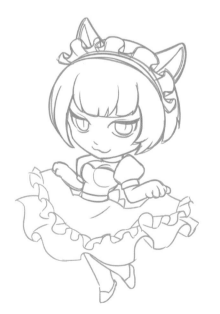
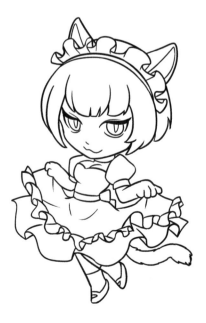
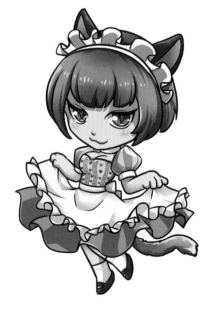

# MANGA MYTHS & LEGENDS

In this final section, I will teach you how to draw manga figures based on myths and legends from lots of different cultures. As many of these creatures, gods and monsters are generally believed to be imaginary, you are going to need a wild imagination to create them! After following the examples in this book, please don't stop there – go on and combine together elements from different figures to make something unique yourself!

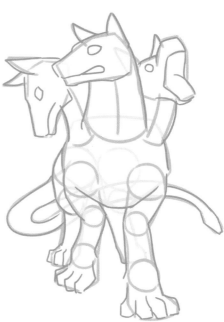
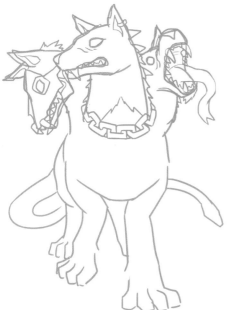
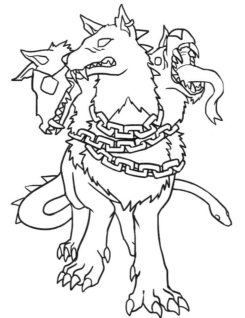
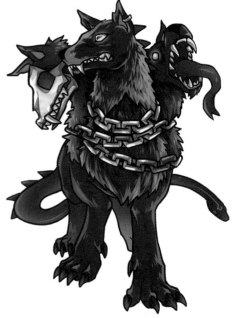

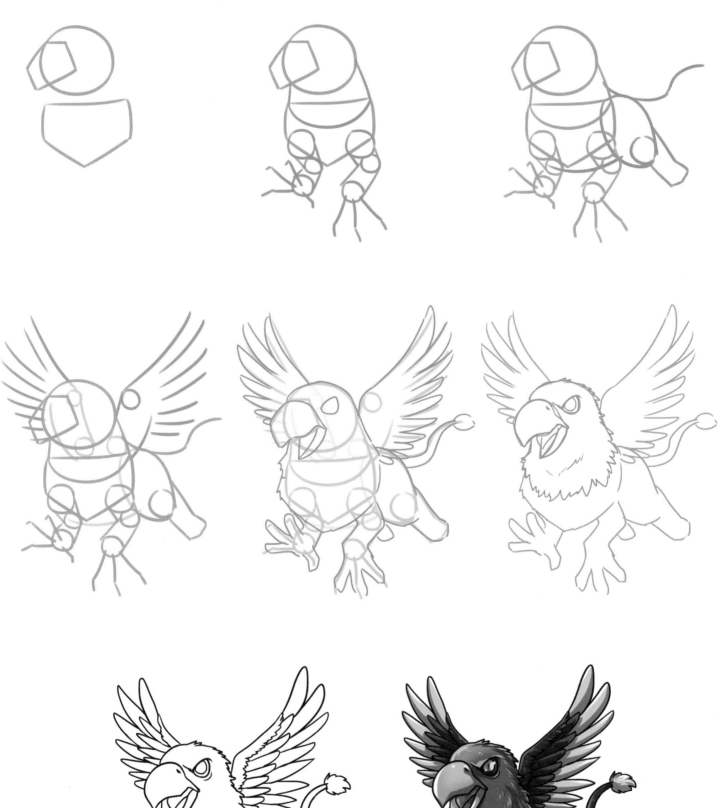

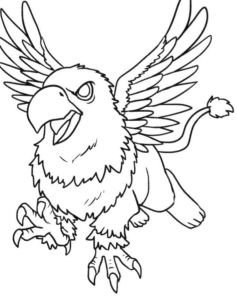

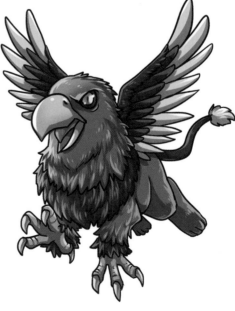

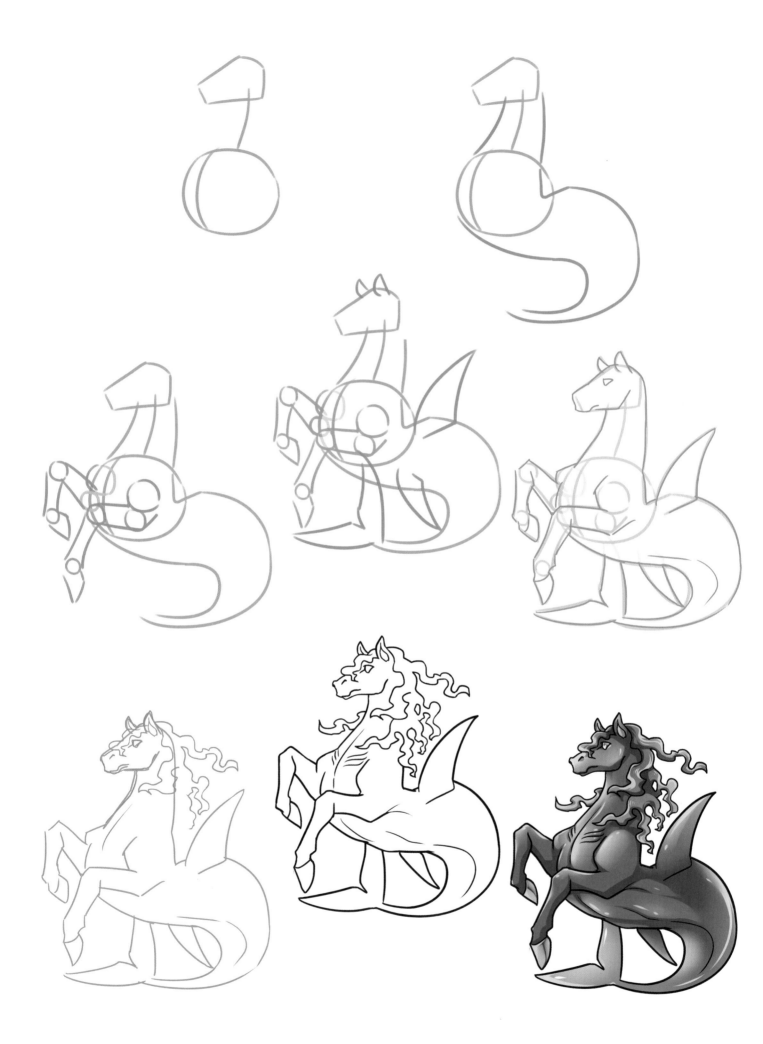

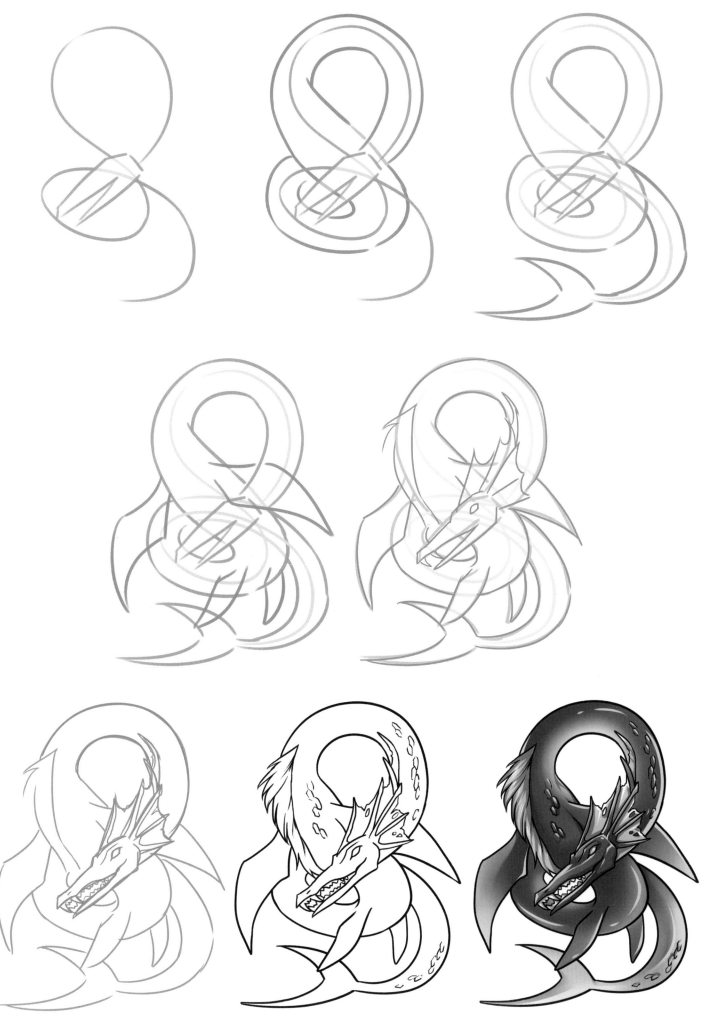

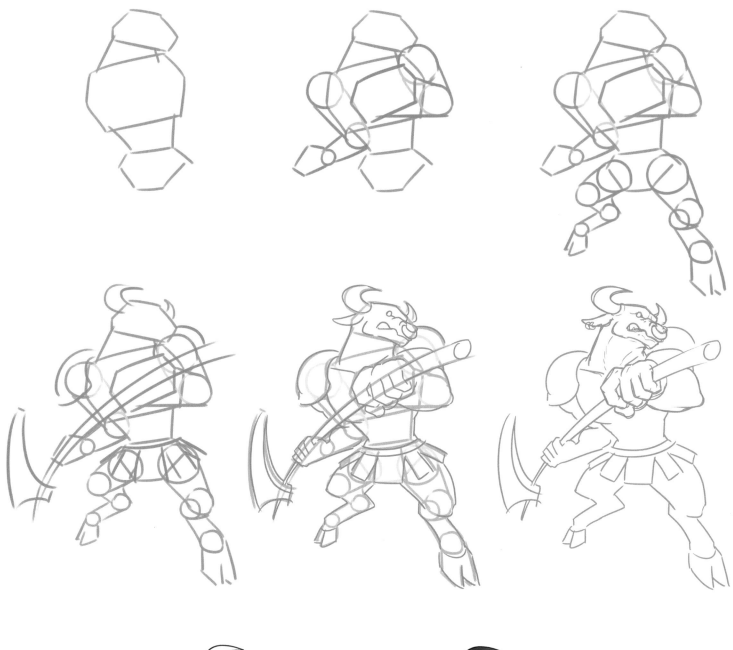
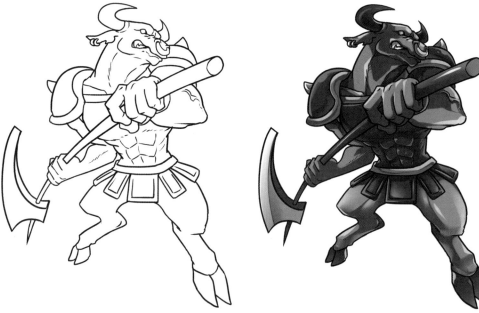

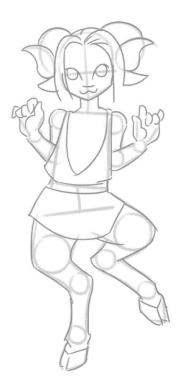
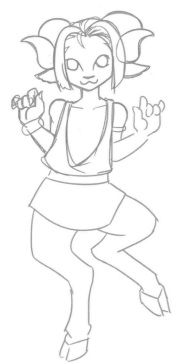
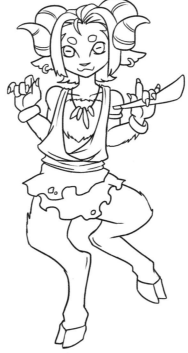
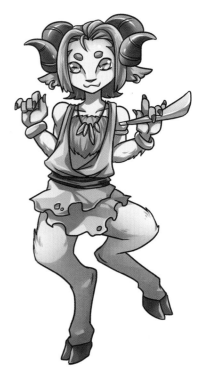

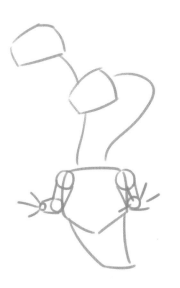
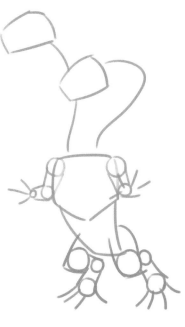
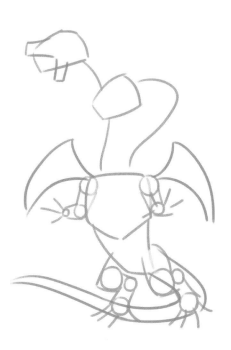
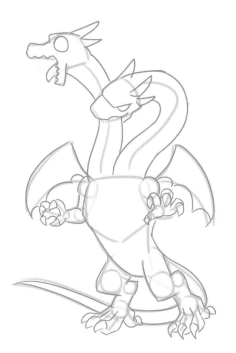
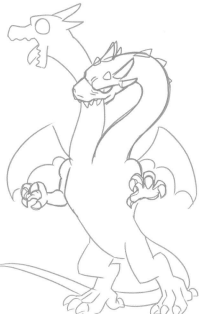
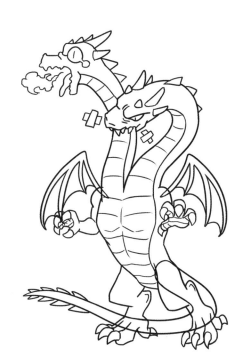
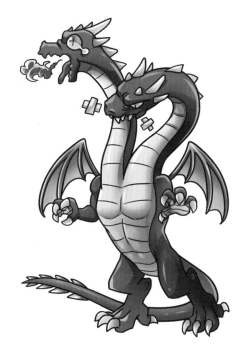

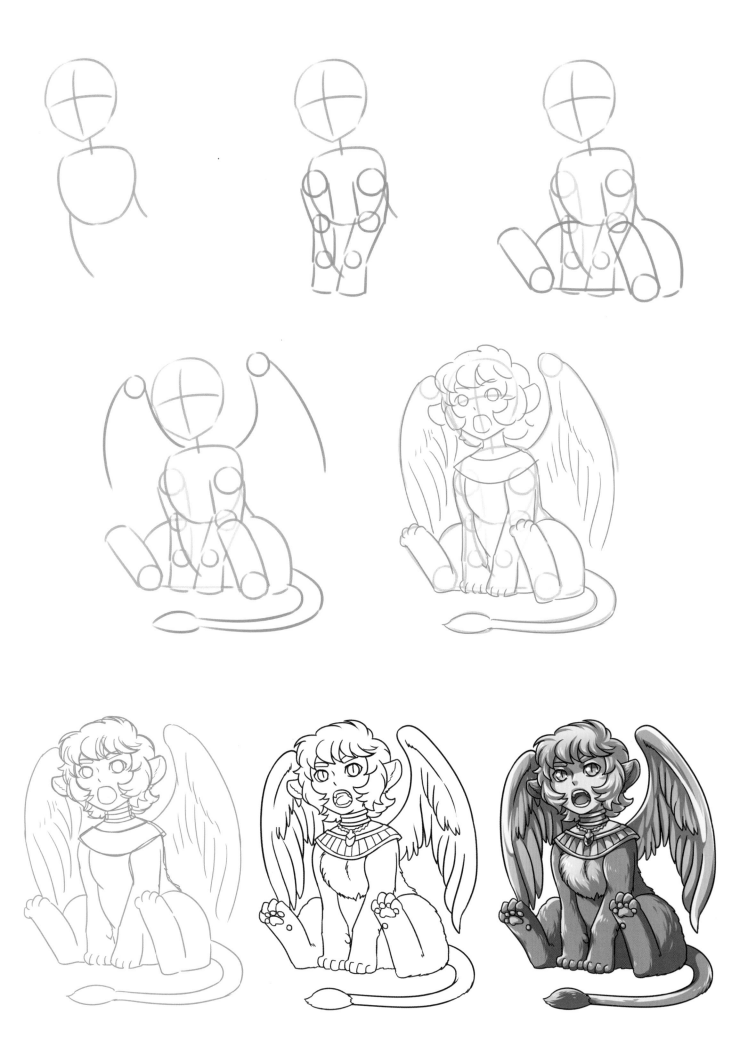

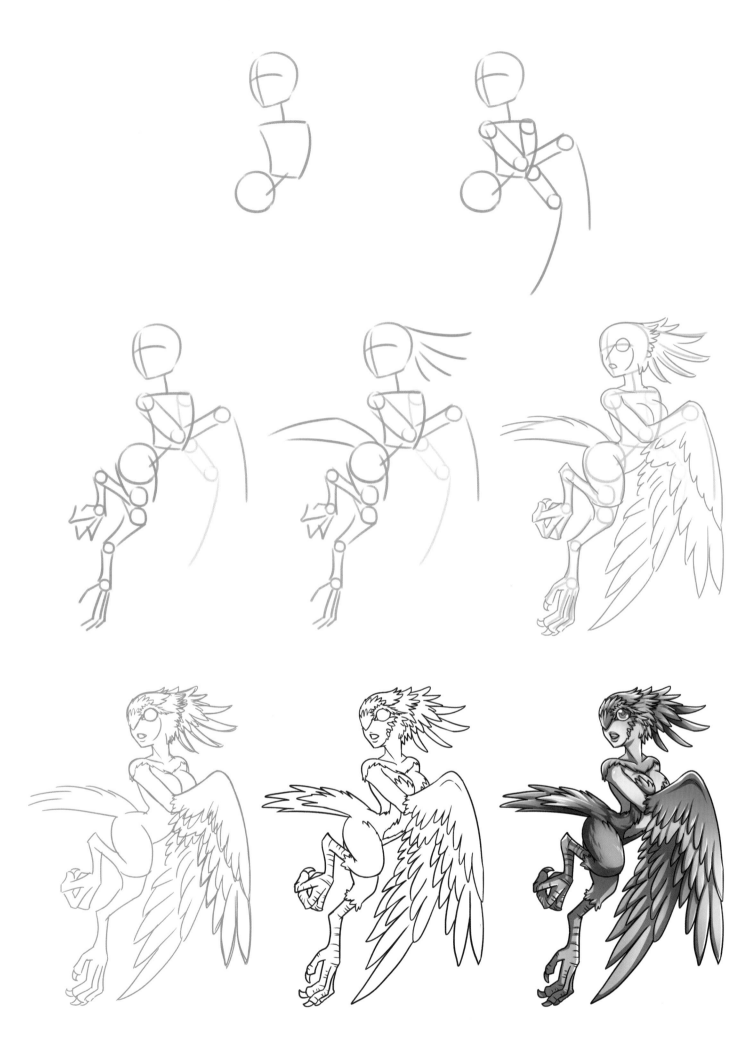

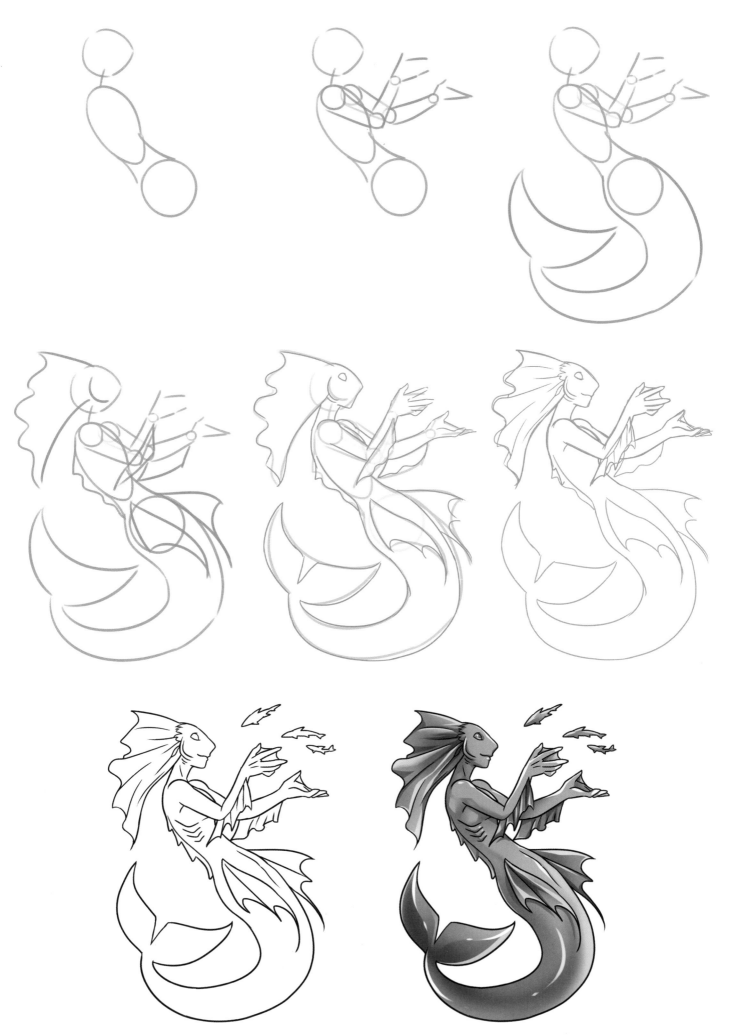

129

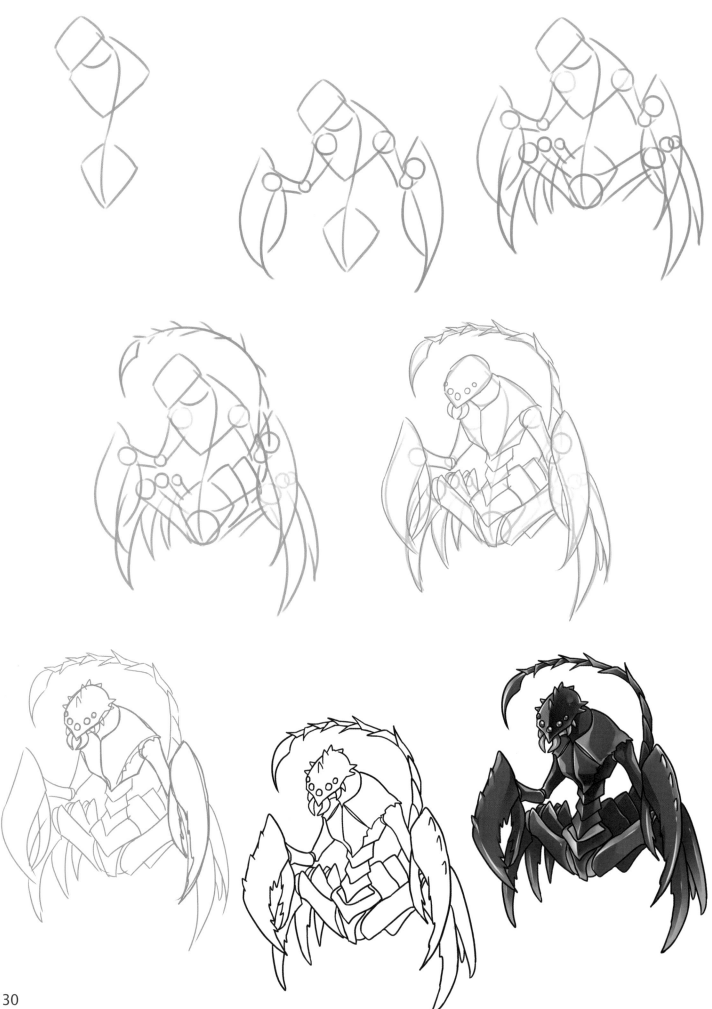

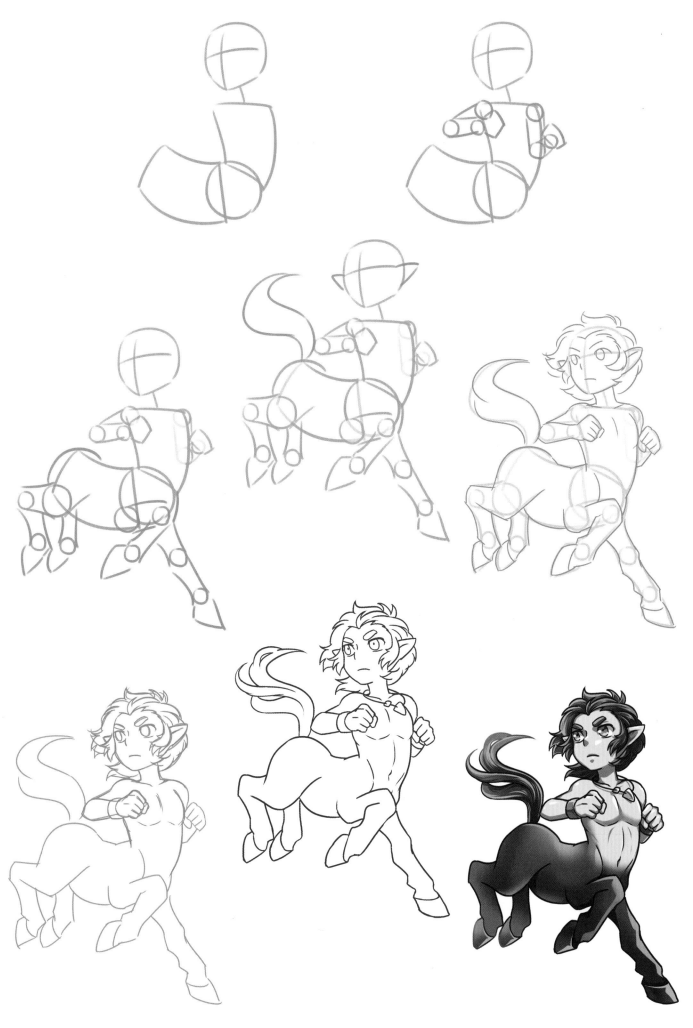

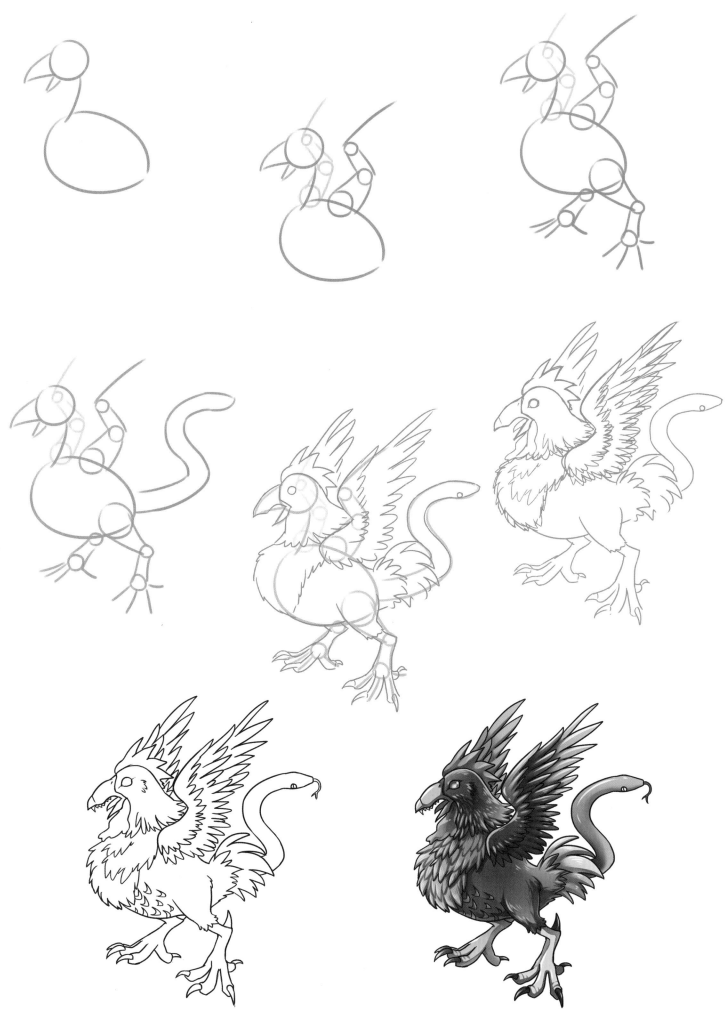

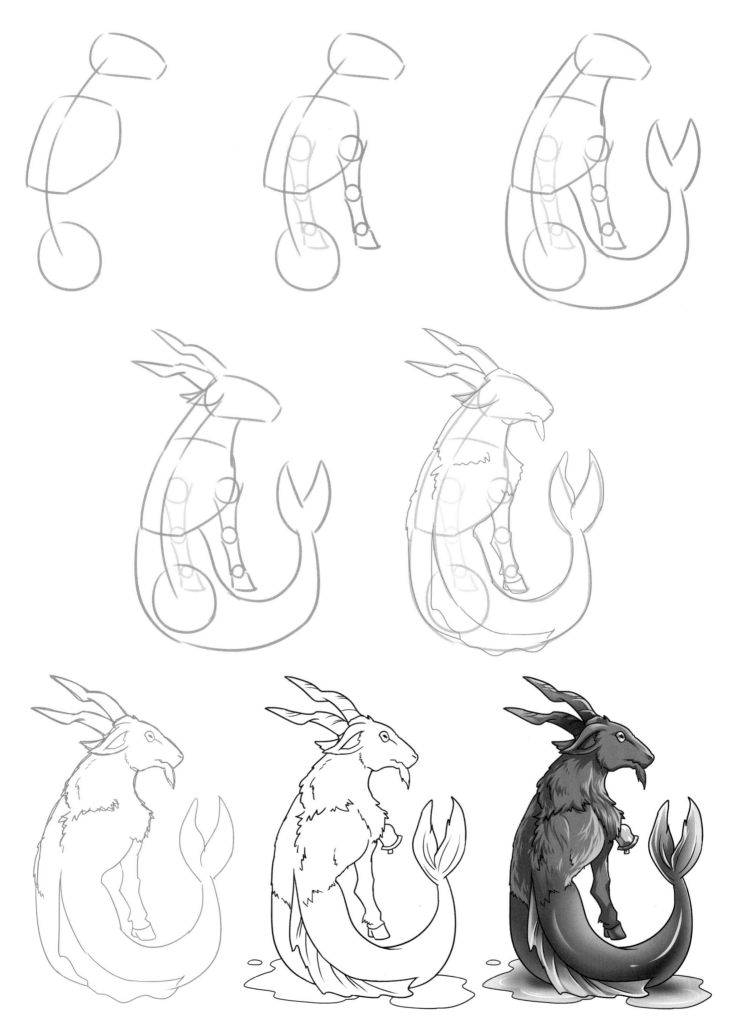

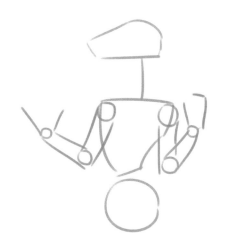
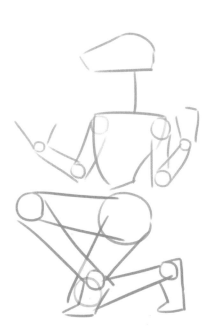
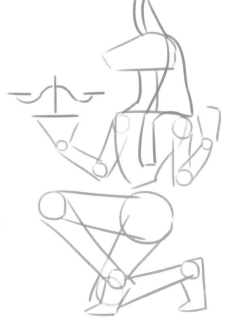
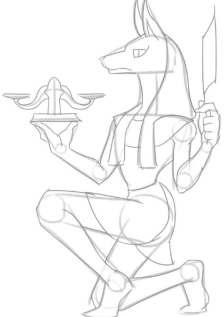
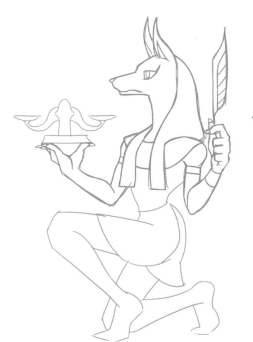
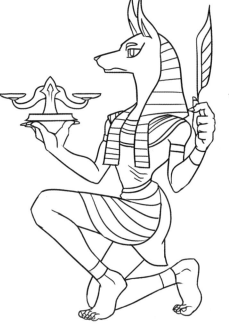
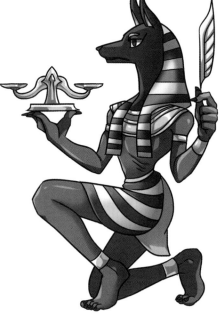

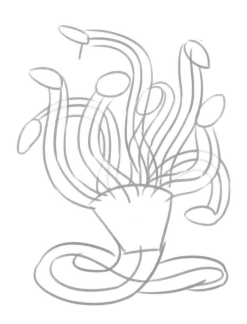
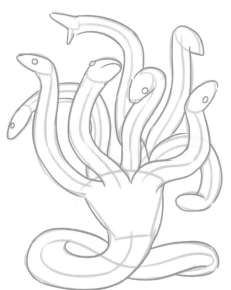
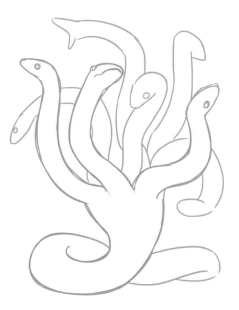
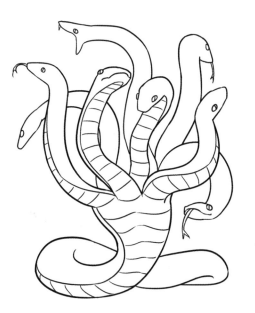
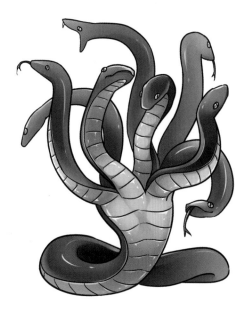

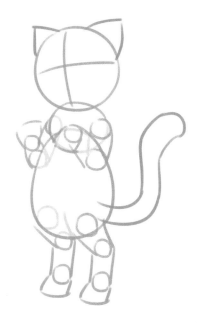
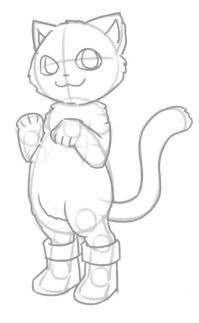
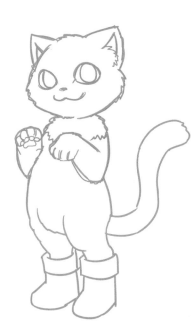
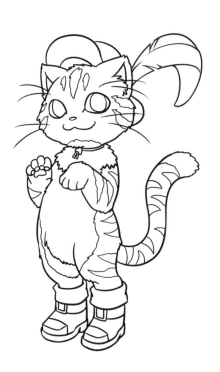
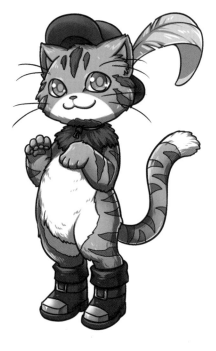

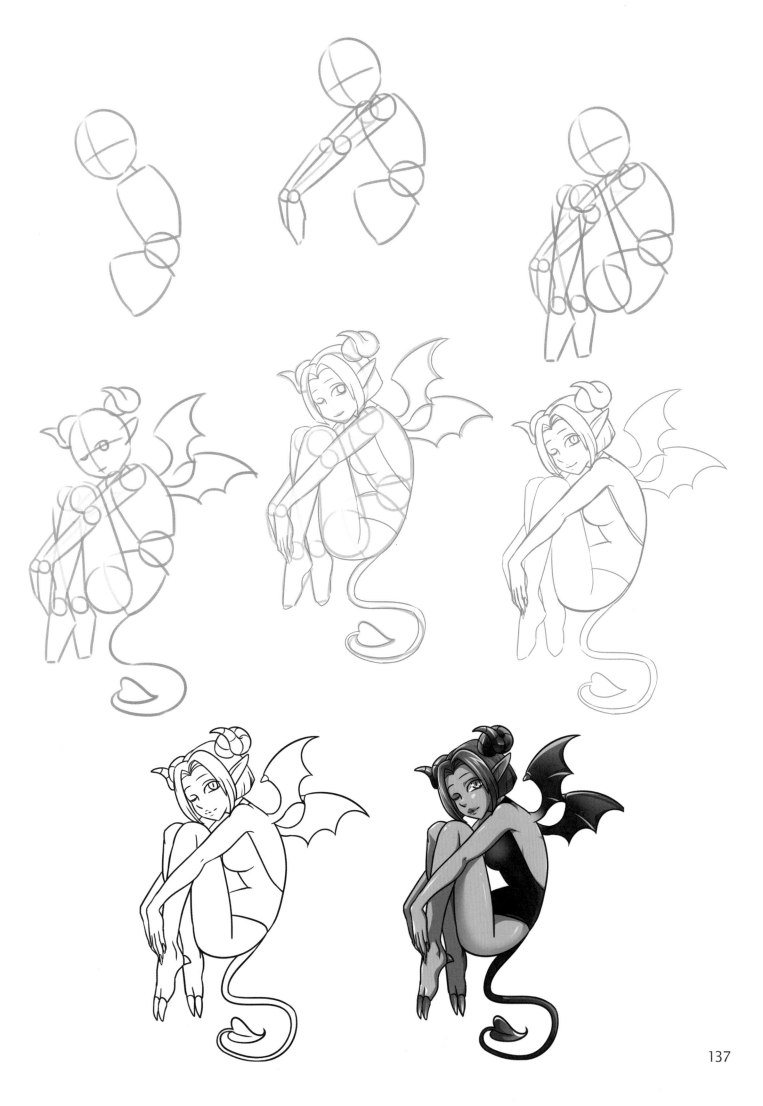

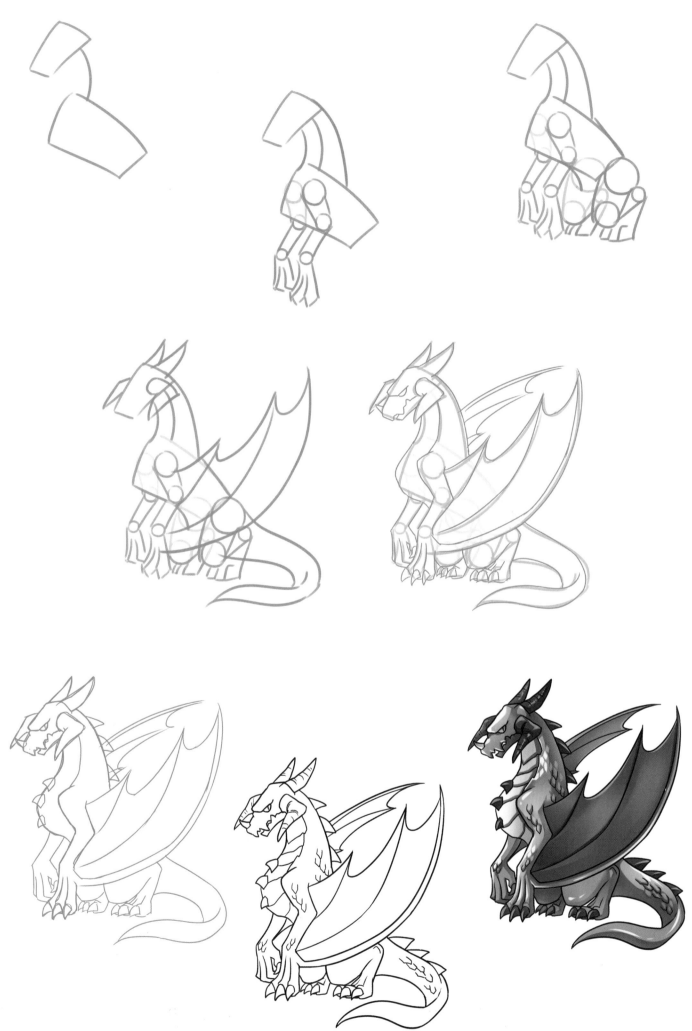

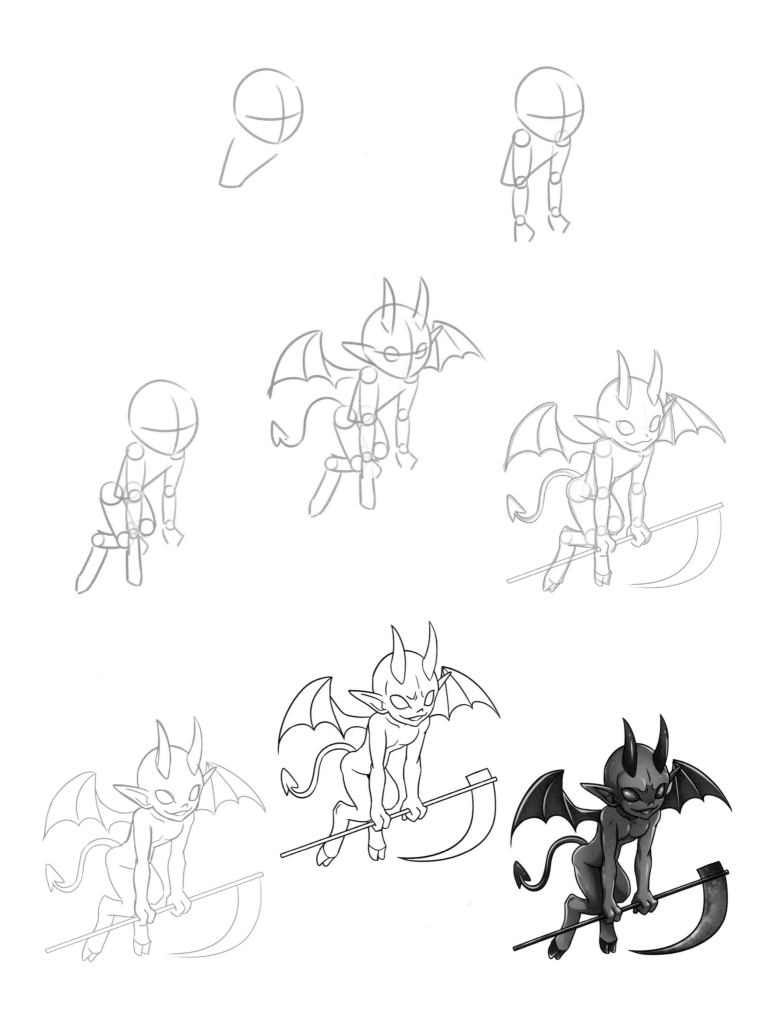

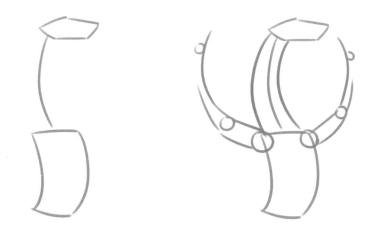
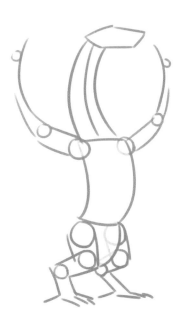
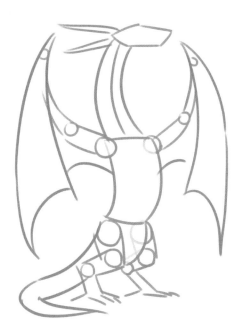
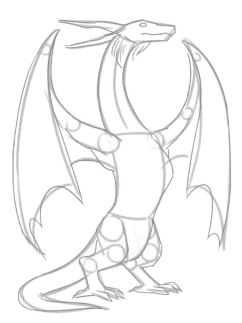
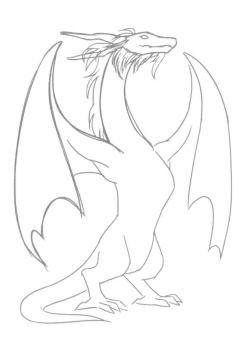
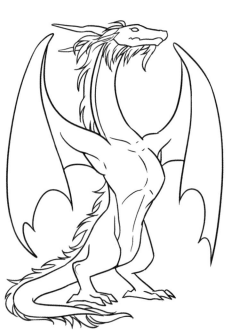
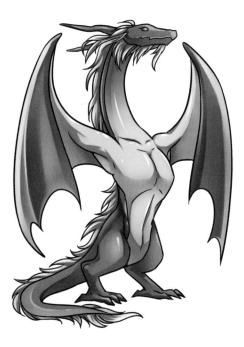

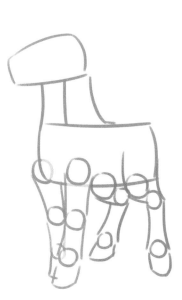
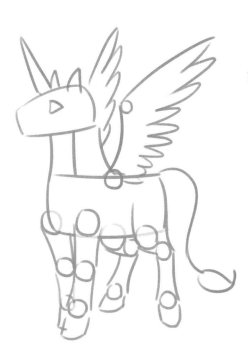
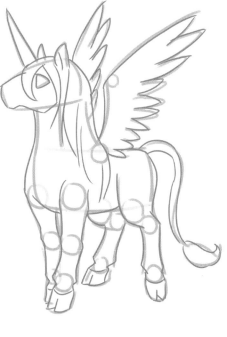
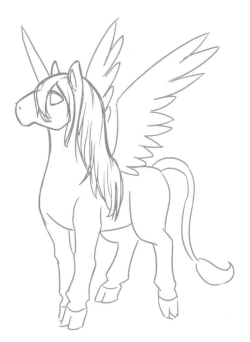
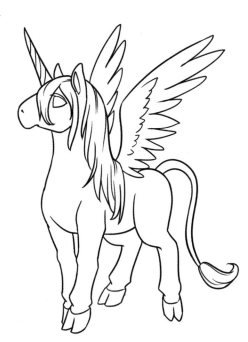
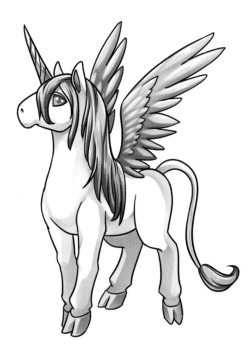

141

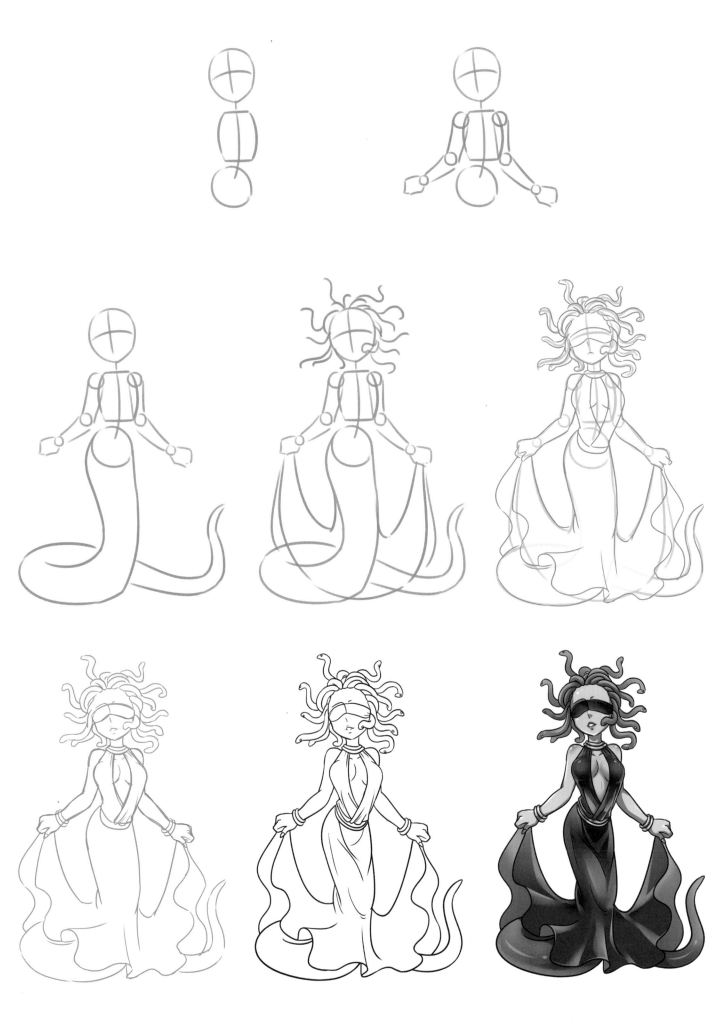

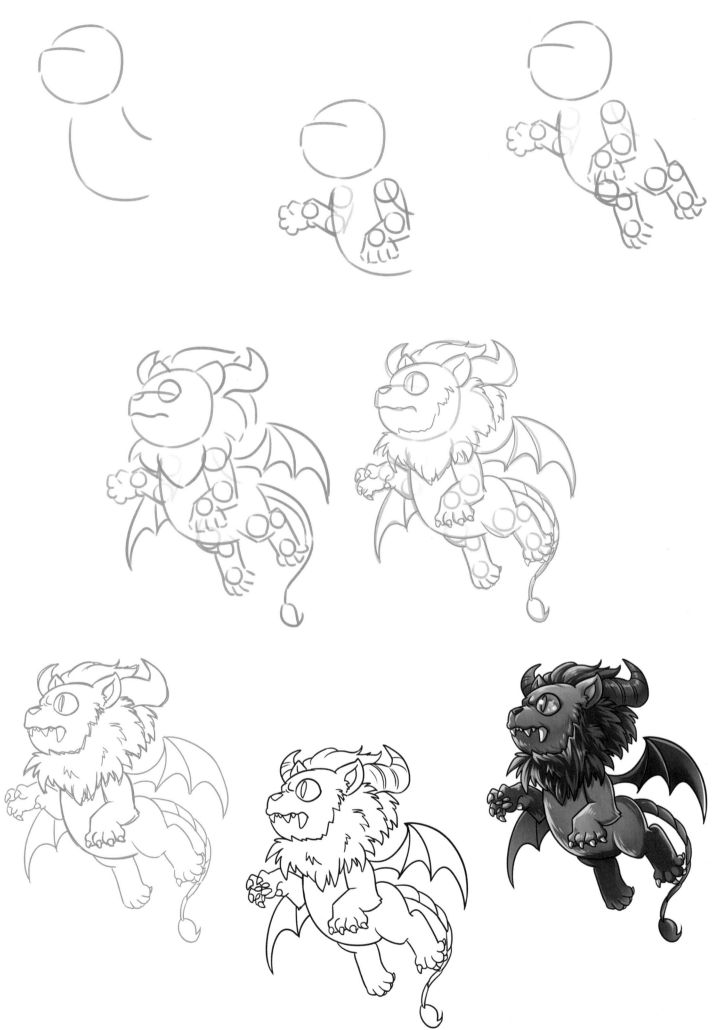

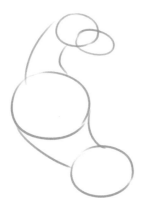
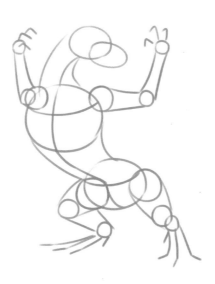
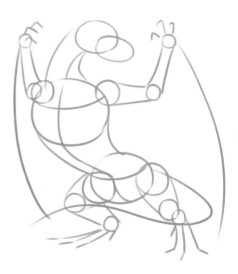
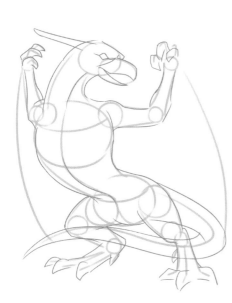
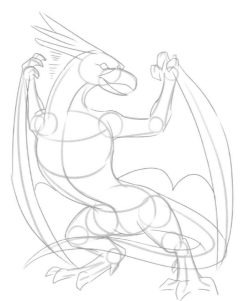
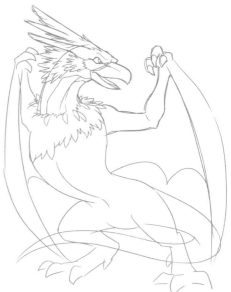
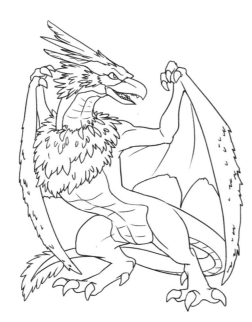
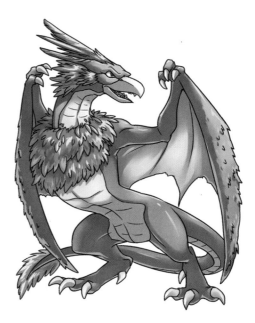